INSIDE
AVIATION
PHOTOGRAPHY

Techniques for:
- In the air
- On the ground

Chad Slattery

AMHERST MEDIA, INC. ■ BUFFALO, NY

Acknowledgements

Profound thanks go to **Caroline Sheen** and **Linda Shiner** at *Air & Space/Smithsonian* magazine for unstinting support and lots of rope with which I only occasionally hung myself; the late great **George Hall** for patient mentoring; **Clay Lacy** for letting me fill George's unfillable shoes; **Beth Wolfe Miles** for best-ever photo flights aboard Wolfe Air's Learjet N49WA; the multi-talented artist/writer/editor/historian polymath **Mike Machat** for endless encouragement and generous wisdom; **Jill Benton** and **Liz Jones** at AOPA for assigning me to photograph the world's best pilots; **John Aldaz** for his long friendship; **Beth Alesse**, my patient editor at Amherst Media; photo consultant **Deanne Delbridge** for encouraging me to combine my passions for aviation and photography; **Tom Twomey** for an introduction to the wild world of Northrop Grumman; **Scott Cutshall, Anne Marie Fithian, Laura Hockemeyer, Zach Rutledge,** and **Denise Wilson** for supporting my business jet habit; and finally **Mom**, for letting me mooch her Brownie Hawkeye camera on my twelfth birthday.

Published by:
Amherst Media, Inc., P.O. Box 538, Buffalo, N.Y. 14213
www.AmherstMedia.com

Publisher: Craig Alesse
Senior Editor/Production Manager: Michelle Perkins
Editors: Barbara A. Lynch-Johnt, Beth Alesse
Acquisitions Editor: Harvey Goldstein
Associate Publisher: Katie Kiss
Editorial Assistance from: Ray Bakos, Carey Miller, Rebecca Rudell, Jen Sexton-Riley,
Business Manager: Sarah Loder
Marketing Associate: Tonya Flickinger

ISBN-13: 978-1-68203-312-8
Library of Congress Control Number: 2017949331
Printed in The United States of America.
10 9 8 7 6 5 4 3 2 1

www.facebook.com/AmherstMediaInc
www.youtube.com/AmherstMedia
www.twitter.com/AmherstMedia

Contents

All aviation photographers fly on the wings of those who came before them, and of those along for the ride. This book is dedicated to my lovely and patient wife, **Donna Lee Lubansky**, and to my all-star kids, **Chloe Revery** and **Gabriel Revery**; this terrific trio tolerated (or maybe enjoyed) my many absences while away on assignments. It's dedicated also to photographer/instructor **Ed Freeman**. Ed's demanding Photoshop classes turned me into an OCD, time-is-no-object, postproduction perfectionist, for which I both celebrate him and curse him.

About the Author

Chad Slattery specializes in digital imaging and postproduction for aviation and aerospace clients.

With hundreds of hours experience aboard Vectorvision and Astrovision photo chase flights, no other photographer has logged more flights in specialized Learjets for air-to-air photo missions.

His corporate clients include Boeing, Bombardier, Dassault, Embraer, HondaJet, Lockheed Martin, Northrop Grumman, and Orbital Sciences.

Business jet photography has been another strong focus of his career. His imagery for manufacturers, brokers, charter operators, and completion facilities relies heavily on sophisticated lighting and postproduction techniques. Many of these techniques are described in this book.

Chad is regularly published in *Air & Space/ Smithsonian*, *Aviation Week & Space Technology*, *AOPA Pilot*, *Flight Training*, *Business Jet Traveler*, *Executive Controller*, *Pro Pilot*, and *Volare* magazines. He is a contributing editor at *Air & Space/Smithsonian* magazine, where his photographs have appeared on thirty of its covers. Getty Images represents his stock photography.

His passion for aviation reaches back to childhood; he managed to glue model airplane parts onto the kitchen table on a regular basis. At age twelve, he mooched his mother's camera and began photographing the models skyward through a glass table on the outdoor patio.

In 2000 Chad co-founded ISAP: the International Society for Aviation Photography. He is also a member of NBAA, AOPA, the SoCal Aviation Association, and the Aero Club of Southern California.

Married to Donna Lee, and the father of twins Chloe and Gabriel, Chad enjoys bicycling, reads voraciously, and collects vintage desktop aircraft models. His favorite creative tool is an oft-used Rösle cocktail shaker.

LICENSING AND PRINTS
For information about licensing the images in this book, and for custom prints, please contact the author at cs@chadslattery.com.

Foreword

Linda Musser Shiner
Editor, *Air & Space/Smithsonian* Magazine

Flight and photography have been important to each other from the moment in 1858 when a Parisian named Gaspard-Félix Tournachon, better known by his pseudonym Nadar, drifted up to 1,600 feet in a gas balloon and made the first aerial photograph, a cityscape of Paris. Embracing the advantage of altitude but discovering that balloons were a cumbersome and time-insensitive way to reach it, Nadar soon became an advocate for heavier-than-air flight. His advocacy can be seen as the foundation for the lasting, mutually-supportive relationship between photography and aviation. About a half a century later, the Wright brothers knew that without photographic evidence, no one would believe the preposterous claim that two brothers without scientific training had invented the airplane. Their proof, shot on a North Carolina sand dune, became one of the most famous photographs in history.

These twin benefits—the access to view afforded by the airplane and the badge of authenticity bestowed by the camera—pushed the fields of photography and aviation to intersect over the years, as each stimulated progress in the other.

As the editor of *Air & Space/Smithsonian* magazine, I've benefitted more than most from the friendship between the airplane and the camera. My job is to bring to our audience the best stories and photographs showcasing the history of aerospace and the current experience of flight. The magazine has been more successful in achieving those goals because it has been able to rely on the storytelling of Chad Slattery.

Chad likes to illuminate aviation's hidden corners so that fellow enthusiasts can join him in marveling at the airplanes, people, and activities he discovers there. He found a way into both the Lockheed Skunk Works and the Boeing archives and photographed the airplane models and other artifacts he found. He traveled to the ephemeral Black Rock City in the Nevada desert to portray the pilots who fly to the Burning Man festival. In both cases, he wrote about his discoveries as well as photographing them, bringing the subjects to readers who would not otherwise have seen them.

He and I went together to Bosnia in 2002 to inquire into the first crews assigned to fly and maintain a strange, new aircraft in the U.S. inventory called Predator. Before it launched a single Hellfire, Chad had captured its robotic creepiness for the *Air & Space* May 2003 cover. And here is why Chad has produced more *Air & Space* covers than any other photographer: Even his photographs tell stories. For the Predator cover, he bracketed the robot with the crewmen who kept it flying to emphasize the man-machine divide. Because of Chad's aviation knowledge and his appreciation for the beauty of airplane design, his portraits of airplanes show readers what they should know about each aircraft he photographs. A Boeing Stearman N2S, which trained so many Navy cadets to fly during World War II (including George H.W. Bush) gleams above a sparkling sea. (I liked this November 1994 cover so much that a 20x30-inch print is framed and hanging in my home. It's one of my favorite works of art.) "I've tried to expand the concept of aviation photography," Chad once told me, "by learning to take portraits, light aircraft, shoot air-to-air, work in Photoshop, craft story proposals, and write articles."

Enjoy the stories Chad tells in this book. They combine the wonder of a young boy looking through the airport fence with the skill of a professional journalist. They blend the mastery of the technical discipline of photography with a deep knowledge of aviation. This book represents another happy marriage of the camera and the airplane.

Introduction

Welcome to the exciting world of aviation photography, where the sky is never the limit. This book is for anyone who has ever looked at photos in airplane publications or online websites and wondered: how did they do that? If you have a fascination with aviation and a bit of curiosity, you're at the right place. If you're handy with a camera, all the better.

The book's intent is simple. For enthusiasts, it is an invitation to join me behind the scenes as I imagine, plan, and create photographs that explore aviation's limitless horizons. For photographers wondering what opportunities the field offers, it offers insight into the challenges and rewards of becoming a specialist—with techniques included to hone your skills. And if you're already a professional, it will encourage you to become not just an airplane photographer, but an aviation photographer.

That distinction is worth noting. Airplane photographers take pictures of aircraft, period. Aviation photographers ideally speak the idiom, enjoy aeronautical history, know Aardvarks from Zlins, study lighting techniques, craft portraits of pilots as well as planes, read the trade magazines, propose and possibly write stories, and can produce magazine articles that editors crave. They might even be pilots.

Inside Aviation Photography showcases 117 photographs. A brief account accompanies each one, describing the thought processes that drove my approach to the aircraft, personality, or artifact. There are also recommendations (PocketWizards for everything!), sure things (360-degree orbits), a business jet checklist, aircraft trivia, and a whole page of mistakes I'm sharing so that you won't copy them. My hope is that you'll use all this information to develop your own creative vision.

Aviation loves acronyms. This book spells them out the first time they appear. Most are common, and easily recognized by aviation enthusiasts.

Photography, on the other hand, loves gear. This book calls out each piece of equipment by its full name the first time it's cited, and by its familiar name after that. A detailed list of my favorite tools appears at the end of the book. But photo equipment changes so fast that the list might as well be called "A Guide to Obsolete Stuff." The one thing they all have in common: nobody has paid me to recommend them.

Neither aviation nor photography stays still for very long. Cameras, web pages, airplane types, and even airplane makers come and go. Everything in this book was meticulously checked for accuracy, but by the time you read it, something will have changed; I just don't know what it'll be. Don't blame me.

Sharp readers will note that registration markings—called "N" or tail numbers—are missing from the business jet photographs. Private jet owners pay dearly to protect their anonymity. Aviation photographers who disrespect that privacy enjoy short careers.

Photographer Alen MacWeeney once observed that "photography is tinged with people with a short attention span and voyeuristic tendencies." It's been my good fortune, as a professional aviation photographer for the past twenty-five years, to precisely fit this description. Whether you mine this book for its technical nuggets, or simply enjoy peeking over my shoulder at the photos, here's wishing you a good flight through its pages.

Chad Slattery
Los Angeles, California

Boeing 787-9 Dreamliner

Favorite photo, favorite photo platform

Push me to pick a favorite photo from my career, and you'll get this view of Boeing's 787-9. Ask for my favorite airplane to shoot from, and you'll hear psalms sung in praise of the Learjet 25B.

In pursuit of the perfect aerial picture, I've strapped into everything from flimsy ultralights to supersonic fighters. But the Learjet has been the best. It's nimble, it's fast, and it's versatile. Attach its underwing camera pod, take off like a rocket, and three minutes later you are comfortably perched atop a two mile-high movie dolly weaving across the sky at 300 mph.

This mission was typical. Most photo flights originate when a marketing department needs new air-to-air imagery of an aircraft. Here, it was Boeing. The company reached out to Wolfe Air Aviation requesting video and stills

of the new 787-9 Dreamliner. The one-day shoot was planned around the jet's flight test schedule. Wolfe Air then contracted with the crew: pilot/aerial coordinator, copilot, aerial cinematographer, camera technician, and me for stills. We flew aboard the Lear from southern California to the factory at Paine Field in Everett, Washington. While the Lear crew briefed with the 787-9 crew, our camera tech installed the Wolfe Air stills pod beneath the wing. We launched first, then looped back to film the 787-9's takeoff.

Twenty-eight minutes later, this photo happened, flying over the Olympic peninsula's eastern side. Our formation briefly passed under a thin cloud that flattened out the strong sunlight.

Specs: Canon 5D Mark II • 24–105mm at 28mm • $1/500$ second, f/11, and ISO 400

Note: In postproduction, I used HSL sliders to lightly saturate blue and greens, and cloned in the forest areas that had been clear-cut.

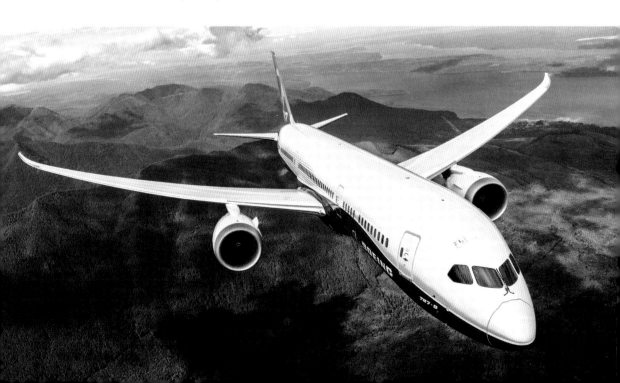

Scaled Composites
Beech Starship

Basics of air-to-air photography

1. The performance of the photo plane (carrying the photographer) and the picture plane (the one you're photographing) must closely match, or one plane will always be trying to catch up.

2. Safety demands that at least one pilot has formation experience.

3. Before every flight, pilots and photographer must thoroughly brief every aspect of the mission. A general guide is that for every hour you fly, the brief should take thirty minutes.

4. Image stabilized lenses with or without gyro stabilizers are critical. They help compensate for rough air and allow the slower shutter speeds necessary to get full propeller arcs.

5. To save time and avoid windblown sensor dust, don't change lenses when airborne. Each lens should have its own camera body.

6. The most versatile lens is a compact zoom in the 24–120mm range.

7. If you are prone to airsickness, (a) take motion sickness tablets (b) carry airsick bags. It is exceedingly rude to throw up in a helmet or onto a seat.

8. Give prints (or send files) to everybody involved in the mission. You'll be remembered kindly, and have your name in front of potential future customers.

9. Do I really need to tell you to shoot huge files, in raw format, and to learn Photoshop?

10. Use a photo platform with a removable door or window. Take gloves, hat and your warmest jacket.

For this image, Robert Scheerer's Starship was photographed over California's Mojave Desert for a cover story in *Air & Space/Smithsonian* magazine. Chuck Coleman flew the Baron 58 photo platform, with the door removed.

Specs: Nikon D100 • 24–120mm at 97mm
$1/60$ second, f/11, and and ISO 200

Notes: You can't see him but that's the Starship's designer, the legendary Burt Rutan, flying N514RS from the right seat.

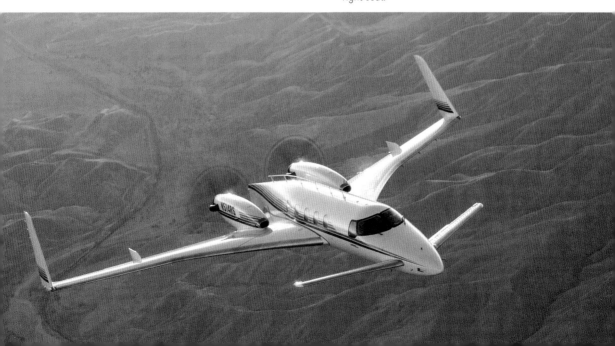

Northrop Grumman B-2A Spirit

Bring backups for your backups

After nearly two years of negotiating with the U.S. Air Force, manufacturer Northrop Grumman received permission to conduct an air-to-air mission with the B-2A stealth bomber. Wolfe Air's Learjet 25B was the photo platform. Security demands exceeded expectations: most aspects of the B-2 remain classified. I was told to bring exactly one camera, one flash card, and one lens onboard; USAF personnel recorded serial numbers of those and the camera/lens combo in the stills pod. No cell phones or personal cameras were allowed. Unfortunately, I was comfortable with that. In twenty-five years of air/air missions, I had never experienced a failure of Canon or Nikon gear. Until this flight.

After exactly two frames with my 5D Mark III/24–105mm zoom lens combination, the camera froze and reported a lens communication error. For twenty expensive minutes the tech and I tried every possible workaround. Lacking a backup camera, I gave up shooting through the Learjet's window and concentrated on the underwing stills camera. Company and USAF personnel were disappointed but gracious—side views out the window would have showed a profile that is not the bomber's best angle anyway.

The moral here: no matter the cost to ship it, or the expense to buy it, or the hassle to convince clients you need it, always have a backup camera and backup lens on an air-to-air shoot. Not a bad idea for any job, but essential when you have exactly one chance to photograph a $1.2 billion bomber that is costing $2,800 every *minute* it's flying alongside you.

Specs: Canon 5D Mark III • 24-105mm at 105mm f/11, ⅟₅₀₀ second, and ISO 400

Note: The day following this shoot, I sent the 24-105mm lens for repair (a new chip) and ordered a second identical lens; I now carry both.

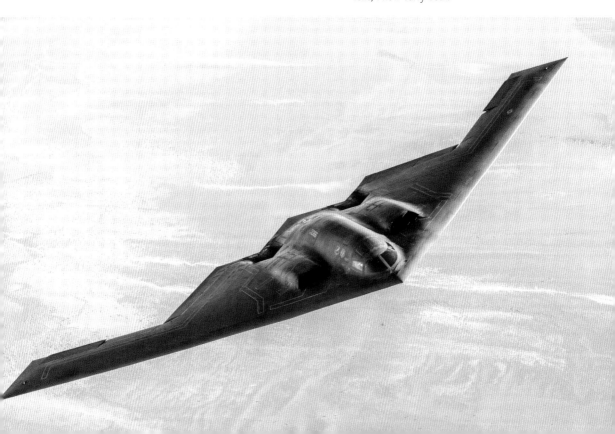

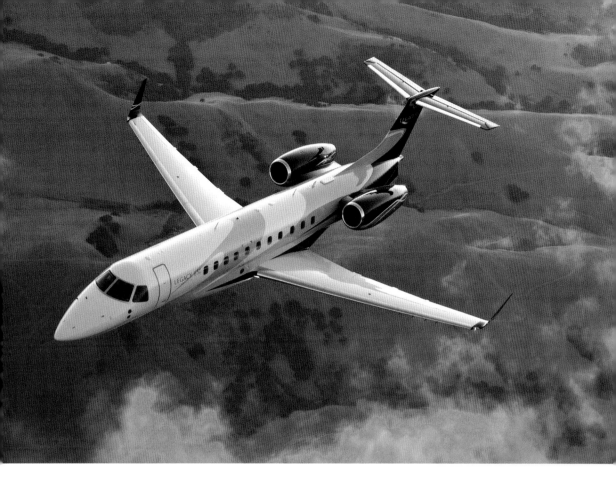

Specs: Canon 5D Mark III • 24-105mm at 73mm
f/11, ⅟₆₀ second, and ISO 1250

Note: I made a mask of the jet in postproduction, then desaturated its yellow cast while enhancing the landscape's golden light.

Embraer Legacy 650

Photographing for print

Sometimes, looser is better. When shooting, widen out occasionally to show less subject and more background. Designers refer to the area surrounding the main subject in a photograph as negative space. Give them lots of it when you can. It gives them the freedom to crop in, to overlay type, and to play with both vertical and horizontal layouts.

I made this photo late in the day with Wolfe Air's underwing stills pod; the original frame shows twice as much background. It can be cropped to make a vertical cover, double page spread, billboard, or web page with no loss in quality.

This freedom to crop explains the preference for cameras that have the highest possible pixel count, but can be comfortably hand held during two-hour flights.

The downside? Huge, 50+ megapixel files need bigger camera cards, sharper (= newer, more expensive) lenses optimized for the digital age, faster computer processing power, and higher capacity storage and backup drives.

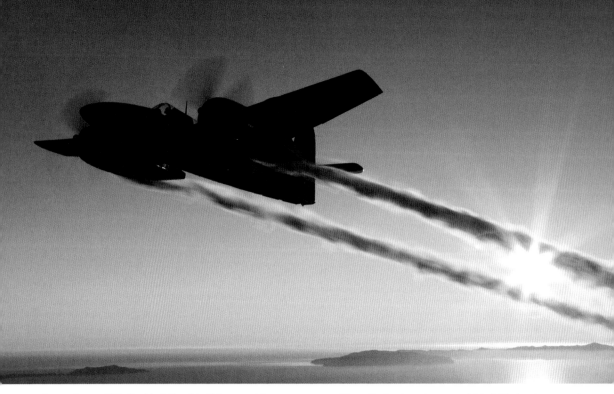

Specs: Canon EOS-1Ds Mark II • 24-105mm at 45mm $\frac{1}{60}$ second, f/16, and ISO 100

Note: Aiming into the sun at f/11 yielded a nice natural star effect, but also produced unflattering flare above the F7F nose.

Grumman F7F Tigercat

Sunset silhouette

For many years, renowned aviator Clay Lacy distributed annual calendars featuring aircraft that have played a part in his storied career. Clay began flying this F7F Tigercat in 2007 and wanted some aerial shots to include in the calendar's 2008 edition.

It was a textbook exercise in what to do right. Clay has decades of formation experience. So does George Hulett, who flew the photo plane. His aircraft, a twin-engine Beech Baron B55-6, has performance characteristics well matched to the Tigercat—and a window that opened to give a clear wide view from many angles.

We launched from KVNY (Van Nuys Airport, Van Nuys, CA) ninety minutes before sunset, worked our way west to the Pacific ocean, and turned north to get ocean and coastal backgrounds. On the return trip south, we passed the Channel Islands. George asked Clay to turn on his airshow smoke, and I asked George to position the F7F between us and the low sun. The challenge was finding a shutter speed slow enough to show the propeller blades spinning, but fast enough to counteract the vibrations from four old piston engines beating themselves up while negotiating the offshore wind chop. I cycled rapidly between shutter speeds of $\frac{1}{30}$, $\frac{1}{60}$, and $\frac{1}{125}$. The middle speed yielded the best results, consistent with my experience that a $\frac{1}{60}$ second shutter speed is your best overall choice for air-to-air images of helicopters and propeller-driven fixed wing airplanes. Second best: $\frac{1}{125}$.

Air Tractor AT-503A

Radio-triggered cameras make unusual aerial viewpoints possible

Throughout the 1960s and 1970s, *National Geographic* magazine's photo technicians invented ingenious equipment enabling photographers to make astonishing pictures from unlikely places. By the 1980s, the technology had trickled down to the rest of us. Nikon began integrating motor drives into its film cameras, and Quantum launched its Radio Slave, able to wirelessly trigger the drives. I wanted to use this cool stuff to give readers views they'd never seen.

So in 1989, when *Smithsonian* magazine assigned a story on crop dusters—they prefer to be called "aerial applicators"—I grabbed my smallest motorized camera, a Nikon F100; 50 rolls of Fuji Velvia transparency film, renowned for enhancing green landscapes; and a Quantum transmitter/receiver set.

Ag pilots routinely fly so low, their wheels brush the crops. We briefed a late afternoon flight that would take us inches above the field in level flight, and into the sun so the spray would be dramatically backlit. I attached a Manfrotto Super Clamp onto the trailing edge duct, as far outboard as structurally safe. I'm a huge fan of the indestructible Leitz 14168 compact ball head, so I used it to mount the F100 onto the Super Clamp. The 16mm semi-fisheye lens was angled backwards, to catch the longest possible spray trail, then tilted down to include the fuselage top and some of the dispenser fan. Focus was put on the large "N" numbers; the shutter speed of $\frac{1}{125}$ was an educated guess that it would be fast enough to counteract the wing vibrations but slow enough to blur the field below. There were no auto-bracketing cameras back then; luckily for me, the guess was correct.

Specs: Nikon F100 • 16mm • Fujichrome Velvia 50 (film) f/5.6, $\frac{1}{125}$ second, and ISO 50

Note: The farm's only green field had already been sprayed with pesticides, so the pilot loaded the Air Tractor's tanks with water for our photo flight.

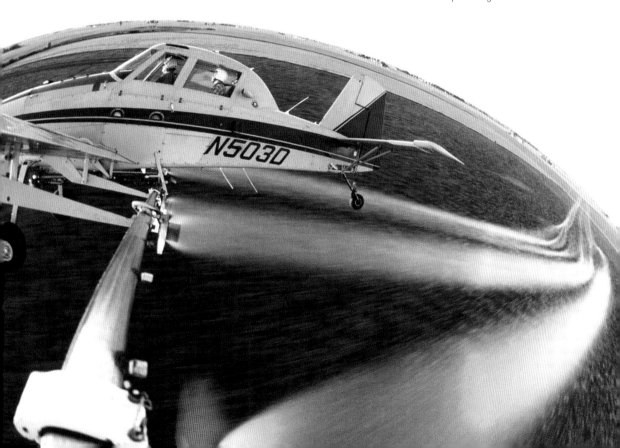

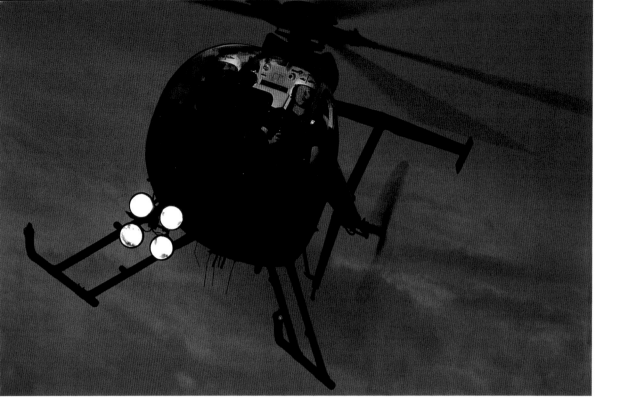

McDonnell Douglas

MD-500E

*Lighting a cockpit with a
remotely-triggered strobe*

Lighting cockpits with a strobe, and triggering it remotely, was easy on the ground. Wanting to push it, I wondered: Would it work in the air? Could pilots fly safely with a blinding light intermittently flashing in their faces?

Enter the Houston Police Department, and an *Air & Space/Smithsonian* magazine assignment on "helicops." I used a Manfrotto Super

Specs: Nikon F5 • 300mm • Film: Fuji RVM Velvia
f/8, ¹⁄₁₂₅ second, and ISO 50

Note: LPA's FlashWizard evolved into today's PocketWizard. The
dusk sky was heavily overcast, intensifying the blue cast.

Clamp and Leitz 14119 mini ball head to attach a Norman 200B lamphead to the instrument panel on a Police MD-500E. Removing the reflector, and wrapping the bare bulb with a full CTO gel, produced a warm-colored cockpit glow that complemented the deep blue dusk sky. An extension cable connected the lamphead to the 200B power pack, tucked under a seat. Last, I plugged a (then new) LPA FlashWizard wireless radio receiver into the lamphead.

As evening approached we tested the setup on the ground by incrementally increasing the distance between me and the MD-500E, triggering the 200B with the FlashWizard transmitter. It was still firing a thousand feet away; the pilots launched.

They followed the plan faultlessly: back off 2,000 feet away at 500 feet altitude, then drive toward the camera with the quad spotlights blazing. The fast Nikon 300mm f/2.8 lens tracked focus perfectly, the strobe recycled nearly instantly, and a cover was born that everyone thought was made in the air.

Boeing-Sikorsky RAH-66 Comanche

Minimizing camera shake in the air with image stabilization

In 1982, The U.S. Army forecast a need to re-place four aging helicopter types, and launched the LHX (Light Helicopter, Experimental) program to develop one brilliant design that could replace all four. A Boeing-Sikorsky team won the contract to build prototypes in 1991; continuing its tradition of naming helicopters after Native American tribes, the Army named the aircraft "Comanche."

Brilliant, it was. It became the first helicop-ter with an all-composite airframe. The land-ing gear retracted into a streamlined fuselage notable for radar-reflecting canted edges. Tail rotor blades nested inside a Fenestron; weapons retracted into internal storage bays. The hot engine exhaust blended with cool ambient air to reduce the Comanche's infrared signature. The combined measures, designers said, would give the aircraft a radar cross section 250 times smaller than its predecessors.

But by 1993 the RAH-66 was being identi-fied as both a technological and cost risk. After its first flight in 1996, I proposed a timeline story to *Air & Space/Smithsonian* magazine on aircraft programs caught up in that decade's tortured defense acquisition process. Early on a hot and humid Florida morning, positioned over the Everglades, I slid open the door, and signaled Comanche's pilot to slowly fly at me. Helicopters vibrate hugely in hover. To coun-teract that, yet use a rotor-blurring slow shutter speed, my camera was attached to a Kenyon KS-6 gyro stabilizer. The KS-6 is a fine replace-ment for, or adjunct with, image-stabilized lenses. It's heavy and useless for panning, but rock steady. When able, I counteract the gyro's weight by suspending it from the photo plat-form's fuselage interior with a bungee cord.

Specs: Nikon F5 • 80-200mm at 200mm
 Film: Fuji RVM Velvia
 f/5.6, 1/125 second, and ISO 50

Note: The RAH-66 was cancelled in 2004, twenty-two years and $6.9 billion after inception. Exactly two aircraft were built.

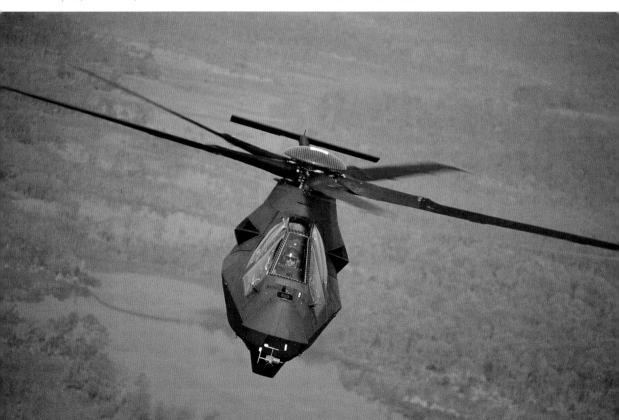

Alaska Airlines Boeing 737-800e

Photographing for airlines: the billboard shot

When Alaska Airlines inaugurated service to Hawai'i, it added a colorful flower lei to the parka worn by the iconic Eskimo featured on the airline's jets. The Clay Lacy Astrovision team was hired to film and photograph a 737 with the new livery as it flew across the islands. Lacy's Learjet 35 was stripped of everything extraneous, then crammed with film equipment and the extra fuel bladders needed to ferry non-stop from California to Honolulu.

This angle, made from the Learjet's front window as we transited open water, was never intended to be creative. It's a straightforward view we call the billboard shot. In just one photograph, the viewer can instantly see:

1. The unmistakable shape of a Boeing 737
2. The airline's name, writ huge
3. Both engines—and they're jets!
4. The sleek, modern winglets
5. The unique tail livery
6. The new Hawai'ian lei, and
7. White clouds below and blue sky beckoning above.
* A bonus: it shows the left side, favored whenever the livery is in a language that reads from left to right.

Hidden just below the frame lay the world's largest fill card: a thick layer of clouds that bounced sunlight onto the fuselage bottom. The shot was made late morning with the sun near its zenith. Without the cloud bounce the jet's underside would go nearly black. The even lighting yields a very versatile photo. Art directors can take an image like this, mask the plane in postproduction, and add whatever background and shading they need.

Specs: Canon 1Ds Mark III • 24–105mm at 93mm f/10, $^1/_{1000}$ second, and ISO 200

Note: To see a fun discussion, ask the internet "Who is the Alaska Airlines Eskimo?"

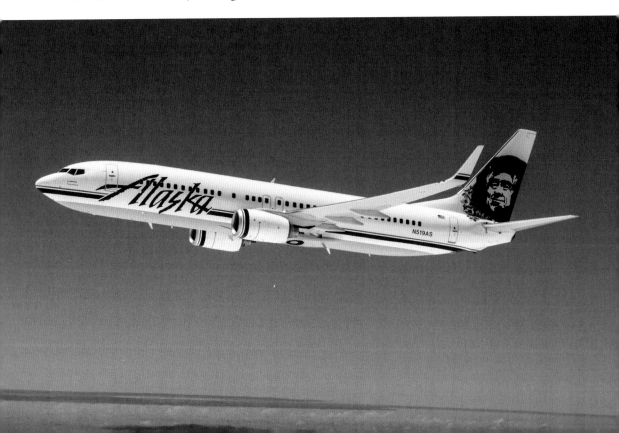

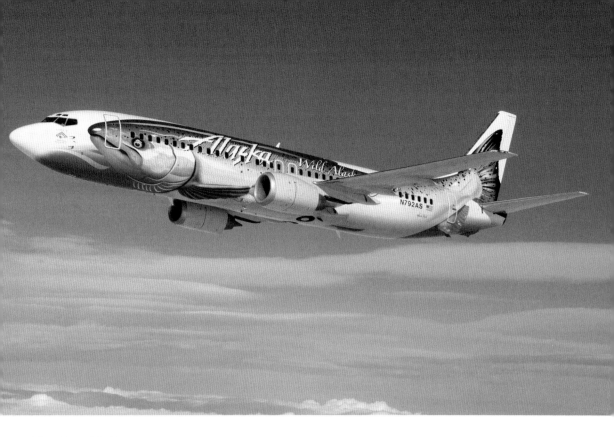

Alaska Airlines
Boeing 737-400

Unusual airliner liveries: the Salmon-Thirty-Salmon

Long-defunct Braniff International Airlines was the first to treat jetliners as canvases. In 1972, eager to promote its South America routes, Braniff commissioned artist Alexander Calder to paint one of its Douglas DC-8-62 jetliners with bright colors and bold designs that would communicate the continent's excitement to travelers. Braniff reaped huge publicity dividends from the "Flying Colors" livery; other airlines took note.

So did industry. Alaska's fisheries have a long relationship with Alaska Airlines; they fly over 30 million pounds of seafood a year to the lower 48. To publicize the partnership, the airline and the Alaska Fisheries Marketing Board commissioned wildlife artist Mark Boyle to create art for a 737. Thirty painters worked 24 days to create what quickly became known as the "Salmon-Thirty-Salmon."

The crew jokes that on this flight we caught a 91,300 pound beauty. We photographed the 737 from all angles. The obvious perspective —a straight-on side view—lacked drama. The special paint also kicked back sun reflections. This ¾ front perspective truncated the "Alaska Seafood" lettering, but the light is perfect and the angle imbues the salmon with anthropomorphic look of "gotcha" surprise.

I shot this through the Learjet 25's front window. To keep the Plexiglas scratch-free I coat a step-up ring with black Performix Plasti Dip and attach that to my zoom lens. That lets me push the lens right into the window's center sweet spot. F/11 always seems to produce the sharpest images there.

Specs: Canon 1Ds Mk II • 24-70mm at 70mm f/11, 1/500 second, and ISO 100

Note: Calder was paid $150,000 for three designs. In 1987, a departing Alaska Airlines 737 flew into a fish; a startled eagle had dropped it.

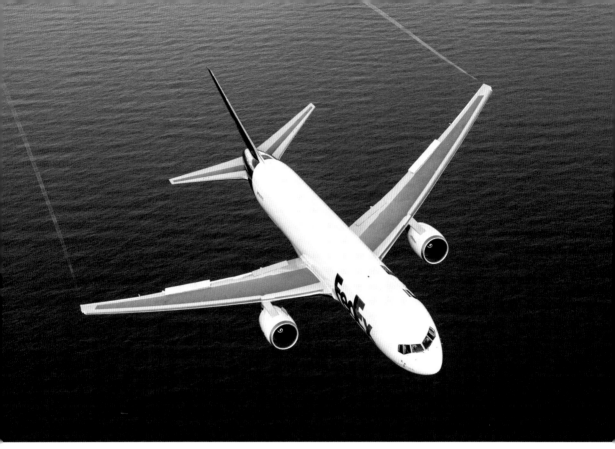

Specs: Canon 5D Mark III • 24-105mm at 65mm f/11, $\frac{1}{400}$ second, and ISO 400

Note: The pilot deployed wing spoilers during this move, to avoid overtaking us. We prefer clean wings, but it saved the shot.

FedEx Boeing 767F

Serendipity aloft—an unexpected vapor trail

The Learjets we fly on photo missions are vintage. Compared to newer Lears, they have limited range and endurance. But they're fast, they hold the right number of crew, and they have wonderfully vintage General Electric CJ-610 turbojets. When the pilot needs to quickly accelerate or throttle back, the engines respond instantly—there is no lag time compared with today's modern turbofans.

But they are also thirsty. When we depart on a mission, we're essentially out of gas. When we're ready to return, we're really out of gas. In between we have two hours and fifteen minutes to make images. The goal is to capture imagery every one of those 135 minutes. Fast, large storage formats—256 GB cards—save the time wasted by swapping out smaller cards.

And you can't ever let your attention wander. This hop with a FedEx 767 freighter had been particularly productive. Positioning along California's Big Sur coastline to film a feet wet/feet dry transition (i.e., from water to land), the jet deployed its outboard wing spoilers and suddenly started trailing visible wingtip vortices. It's a rare sight for airliners, and I was fortunate to be holding the stills pod console. It lasted for 5 seconds; there were six stills total.

Fedex Boeing 767F

Postproduction for a desaturated, high-contrast effect

Judging from sports and action magazines, high-contrast, desaturated male portraits remain fashionable. I wondered if the look would work well with aircraft. It does, but takes some work.

I picked this backlit shot, made with the Wolfe Air stills pod on the same flight that captured the photo on the opposite page. It was taken 30 minutes before sunset. It was a mess. The clouds were warm, and the fuselage was not only underexposed but deep blue from north light. But I liked the even light on the fu-selage, the drama of the backlit clouds, and the potential it had as a black and white conversion.

In Photoshop Raw, I began by cooling the color temperature to 4900 Kelvin. Next, I increased the exposure two stops, then adjusted the Highlights −100 to recapture detail in the clouds. Sliding the shadow adjustment +65 brightened the fuselage. Finally, pushing the clarity slider to +55 popped the clouds and gave the image a contrasty, desaturated feel.

Now the jet and the clouds looked great, but the livery was lost. With another layer mask, I used the HSL (Hue, Saturation, Luminance) red and orange sliders to saturate and brighten the "Ex" in the three logos. Without that, the photo would have looked like a tepid black-and-white conversion.

As a final touch, I brightened the engine intake to reveal the jet engine's spinner; I do this a lot.

Specs: Canon 1Ds Mark III • 24–105mm at 35mm
f/11, 1/1250 second, and ISO 400

Note: This shot would would have lost most of its impact if I zoomed in, cropping out the clouds. Sometimes, more is more.

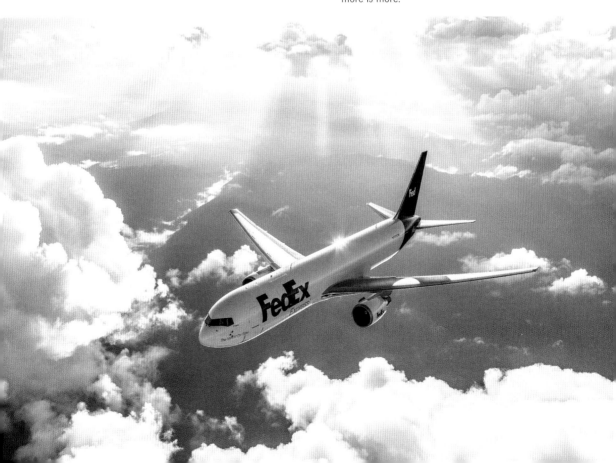

Specs: Canon 5D Mark III • 24-105mm at 40mm
f/11, ¹⁄₂₅ second, and ISO 800

Note: The wing root light adds a surprise note to the photo. Even in daylight, I always request all aircraft lights be turned on.

Emirates Boeing 777-300ER

Camera settings when jets are the picture planes

Emirates (it doesn't use Airlines in its name) operates more Boeing 777s than any other carrier. Wolfe Air was commissioned to photograph Emirates's first –300ER (Extended Range) variant. As with many Boeing product shoots, we ferried the Lear 25B from Los Angeles to Paine Field near Seattle. We refueled, briefed, and prepped the cameras. Launch was, as usual, two hours before sunset.

It has been hard for me to accept that any three-digit ISO will yield perfect photos. That's a leftover from film days, when Kodachrome 25 and then Velvia 50 were the gold standard. But as manufacturers steadily drive down the signal noise from high ISOs, and imagery gets used more on the web than in print, I'm caving. Today my default is ISO 400 for air-to-air shoots. And if I know the flight will go into dusk, I'll go to 800.

That's the setting I used for the underwing stills pod camera on this shoot, and I got lucky. During the pre-flight brief we had requested the landing light be kept on, and the f/11 aperture gave us a natural looking star effect. By the time we turned for home along the Straight of Juan de Fuca, the sun had set but the air was extremely smooth. The 777 tucked in behind the pod and the Boeing test pilots held it rock steady as I slowly squeezed off exposures. Unfortunately stills pod settings cannot be adjusted in the air, so I couldn't adjust the aperture or ISO. Amazingly, the focus stayed accurate, and I got this one perfect photo—at the unbelievably slow shutter speed of ¹⁄₂₅ second.

Eva Air 777-300ER

Composition, zoom lenses, and the rule of thirds

I switched to Canon cameras when the EOS-1Ds became the first professional digital camera with a full-frame (24x36mm) sensor. I initially relied on Canon's 24–70 f/2.8 zoom during aerial shoots. I switched to Canon's 24–105 f/4 lens when it became available in 2005, happy to trade one f-stop for longer range and the addition of image stabilization. It remains the ideal choice for aerial work.

The images from photo flights, both stills and video, can easily have a lifespan of ten years if an airline's livery remains unchanged. They will find their way into print ads, web sites, TV commercials, magazines, calendars, billboards, and corporate offices. But the ultimate customers will usually be art directors, whether inside the client's company or at its advertising agency. Our job is to give them a visual library with as many variations as possible; after editing, I typically submit a minimum of 750 photos.

The Pacific Northwest, home of Boeing's commercial aircraft factories, offers tremendous scenic choices: ocean, straits, islands, forests, snow-capped mountains and urban backgrounds are jet minutes from each other. In flight, the Lear becomes a jet-propelled aerial dolly that facilitates verticals, horizontals, close-ups and 360-degree views.

But the baseline view remains this horizontal billboard shot, based on the classic rule of thirds for a balanced and pleasing composition. It's versatile, and easily made into a billboard, magazine ad, or web image. This image was made shortly after takeoff as our formation leveled off heading for the Pacific Ocean.

Specs: Canon 1Ds Mk II • 24-105mm at 105mm f/13, $\frac{1}{250}$ second, and ISO 100

Note: I used Photoshop's HSL adjustments to remove late afternoon yellow cast and enhance the blue tones, then added a blue sky gradation.

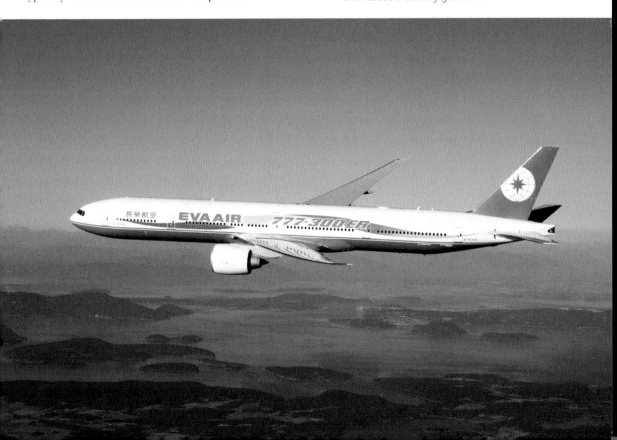

Bowlus BA-100 Baby Albatross

Photography on Silent Wings

For a story on vintage gliders, this elegant 1939 Hawley Bowlus design was a natural subject for a formation photo flight. We considered a small helicopter as photo chase, but it would have cost much more and been much less fun. So following my own advice to use a platform that flies like the picture airplane, my ride was a WWII Laister-Kauffman LK-10A sailplane based at Mountain View Airport, nestled at the foot of southern California's Sierra Nevada range.

The LK-10A is an old training glider, but safe: Doug Fronius, Northrop Grumman's Chief Engineer for Aircraft Programs, had done a ground-up restoration. We aero-towed to 6,000 feet, released, dove beneath the BA-100 (because top light made the translucent wings glow), and then flew slow orbits around it all the way to touchdown. This shot was used later as a book cover: remembering more of my own advice, I had shot some verticals during the descent.

Specs: Nikon F5 • 80–200mm at 80mm
Fujichrome Velvia (film)
f/8, ¹⁄₅₀₀, and ISO 50

Note: Purchased as a kit in 1938 by 3 Boeing engineers, it was not built until 1968. Empty weight is only 312 lbs.

Boeing Strearman N2S-4

Air to Air from a Helicopter

Air & Space/Smithsonian magazine's photo editor, Caroline Sheen, assigned me to find a Stearman in the Los Angeles area and take photos for a cover feature on that timeless biplane's many lives. Stearmans were traditionally painted bright yellow. Looking down on one as it flew over the blue waters of nearby Santa Monica Bay would not only offer a nice color contrast, but also leave plenty of negative space for the magazine to overlay the logo and story headlines. Through the Santa Monica Museum of Flying, aviation attorney Patrick Bailey volunteered his N2S-4, and "volunteered" fellow pilot Bob (now Zoey) Tur to fly me in an AS350B helicopter as the photo platform.

The Stearman and helo departed Santa Monica Airport late in the afternoon as a flight of two. We found a patch of clear-blue ocean, and the helo went into a hover. Patrick made a number of slow passes below us. When looking down on a prop-driven airplane, there's no propeller arc to capture; fast shutter speeds are acceptable. In this shot, panning at $1/500$ shutter speed counteracted the vibration that all helicopters experience when hovering, while making motion streaks from the water highlights.

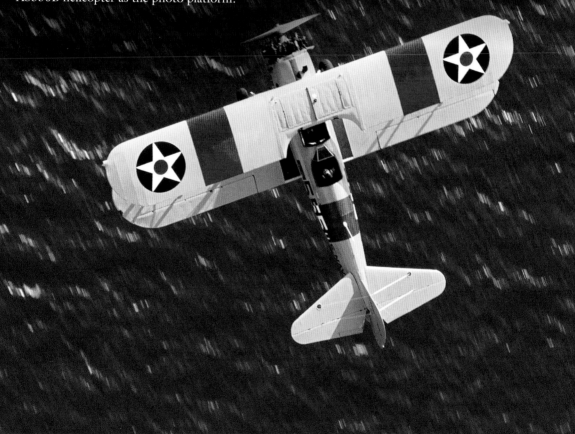

Specs: Nikon F4 • 80–200mm at 200mm
Fujichrome Velvia (film)
f/5.6, $1/500$ second, and ISO 50

Note: Twenty-five years later, stored in archival sleeves inside a climate-controlled room, this Velvia slide still looks new.

Bellanca 8KCAB Super Decathlon

Inverted with a remotely triggered camera

The assignment, from AOPA's *Flight Training* magazine, was to photograph Rich Stowell's Emergency Maneuver Training course for a dramatic cover. The Nikon 8008's small size made it a perfect fit under wing, attached with a Manfrotto Super Clamp and Leitz 14110 ball head. The 16mm semi-fisheye lens not only took in the entire plane but also conveyed the disoriented perspective that's central to the course. Gaffer tape held the Quantum Radio Slave 2 transmitter next to the camera, linked to it with an electronic cable release. I sat in the back seat and triggered the camera as Rich flung the Decathlon through an astounding variety of stomach-churning maneuvers.

Specs: Nikon N8008 • 16mm f/2.8 AI-S
Fujichrome Provia 100F (film)
f/11, ½₂₅₀ second, ISO 100

Note: Bonine, an over-the-counter antiemetic, is very effective at counteracting motion sickness, with very little of the drowsiness associated with its counterparts.

Schleicher ASK-21

Always shoot verticals—you just might get the cover

The ride of your life! That was the cover tag on *Air & Space/Smithsonian* magazine's guide to aircraft rides for hire. I was assigned the glider segment. Hoping to snag the two-page opener, I planned a photo that would feature the sailplane but have room for a headline and text: a horizontal with the glider exactly upside down. Still in the camera-on-wing phase of my career, I made a bracket to hold a small Nikon and Quantum's Radio Slave 2 transmitter, and bolted it onto the wingtip. We hitched an aero-tow to 9,000 feet and began making 360-degree loops as I punched away at the radio transmitter. The editors loved the choice of angles, and picked a shot of us going vertical as the cover.

Specs: Nikon N8008 • Nikon 20mm f/4 AI
Fujichrome Velvia (film)
f/8, ⅟₅₀₀ second, ISO 50

Note: The small Nikon and the very small 20mm lens fit perfectly on the wing. After focusing the lens on the letters, I taped the barrel to minimize any chance of slipping. The camera was set to shutter priority; the film lab did a snip test of the film to confirm that the auto-exposure was accurate.

Surf Air Pilatus PC-12/47E

Computing shutter speed for a good propeller arc

Surf Air, the California subscription airline, needed aerial video and stills showcasing a Pilatus PC-12. The company especially wanted the unusual vantage offered by the Wolfe Air stills pod. The pod's camera settings, however, couldn't be changed once airborne. So the challenge was using shutter priority with a speed slow enough to get a decent propeller arc, but fast enough to counteract vibrations from our Cessna 337 photo plane. It's a problem for every photographer shooting propeller-driven airplanes.

One solution is to first photograph the picture plane on the ground, propeller turning at cruise speed, while varying the shutter speeds. Point the aircraft towards the sun to best see which speed gives you a complete 360-degree arc, and use that setting in the air as the basis to bracket around.

Since I couldn't do that with the pod camera, here's the workaround. I looked up the Pilatus's specs; there are four blades, and cruise RPM is 1700. For convenience, I rounded that up to 1800. 1800 revolutions per minute translates to 30 revolutions per second; *i.e.*, one blade goes completely around in $\frac{1}{30}$ second. But it needs to spin only until it gets to where the previous blade was: $\frac{1}{4}$ turn. So at a shutter speed of $\frac{1}{125}$, the four blades spinning will collectively make a full arc.

It works well if the air is smooth and all engines free from vibration. To be on the safe side, a $\frac{1}{250}$ shutter speed would have yielded an incomplete but still photogenic prop arc, with good insurance against vibration. For this shoot, I bumped it down to $\frac{1}{200}$; moderate risk, good return.

Specs: Canon 5D Mark III • 24-105mm at 73mm
f/20, $\frac{1}{200}$ second, and ISO 400

Note: Today's cameras have exceptional resolution; picture plane pilots must look sharp and act professional during filming.

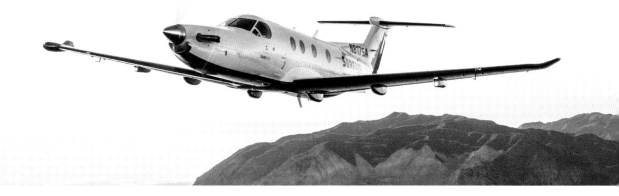

Specs: Canon 5D Mark III • 24-105mm at 58mm
$\frac{1}{200}$ second, f/22, and ISO 400

Note: In Adobe Camera Raw, adjustments were Exposure +1.40, Highlights -63, Shadow +31, Clarity +80, and Saturation +80.

Surf Air Pilatus PC-12/47E

Lessons from the school of hard knocks

"*Ever tried. Ever failed. No matter. Try again. Fail again. Fail better.*" —Samuel Beckett

The "Waiting For Godot" playwright is every professional photographer's patron saint. We make many mistakes; some of them we make, many times. Learn from mine.

1. When you photograph from a Cessna, bring gaffer's tape to keep the window up.

2. Don't assume your photo aircraft has a working headset. Bring your own, and a helicopter adapter.

3. David Clark H10-13.4 headsets are the industry standard. If you're jumping around inside a Learjet or a B-25, wireless Lightspeed Tangos keep you mobile. (I bring both types of headsets.)

4. Learn to shoot, edit, and postproduce video. It's the future. Don't neglect audio.

5. Leave your lens shade at home. In a Lear, it'll scratch windows; through an open window or door, it'll be a sail.

6. When directing picture planes with hand signals, wearing orange gloves makes it easier for the pilots to see you.

7. Paraphrasing Oscar Wilde, I have the simplest tastes—I am always satisfied with the best. Buy the newest cameras and lenses you can. They'll last longer, do more, and hold resale value longer.

8. Learn the language. If you can, get a pilot's license. If you can't, take ground school. Know the hand signals for marshalling aircraft. Memorize the names of control surfaces.

9. Buy the fastest, highest capacity data cards your camera accepts. Bring twice as many as you think you'll need.

10. Always take a warm black jacket and watch cap, no matter the ground temperature.

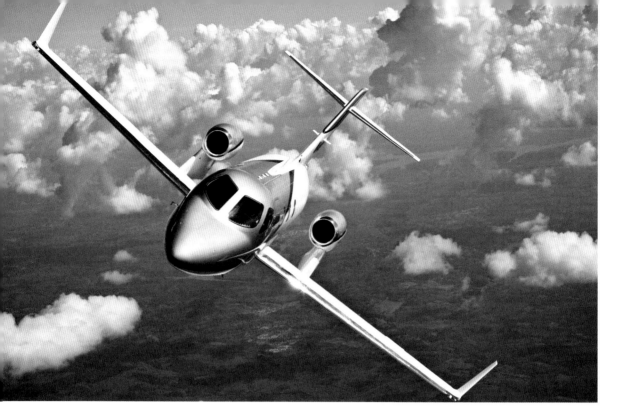

Honda HA-420 HondaJet

*Coordinating aerial
stills with video*

Specs: 5D Mark II • 24-105mm at 70mm
f/11, 1/250 second, and ISO 100

Note: This jet was still in flight test, with a long Pitot
tube on the nose that had to be retouched out.
This was the first flight with the Wolfe stills pod.

Only two jet-powered civilian aircraft in the U.S. can simultaneously film stills and video. Both are Learjets modified with custom ports on the upper and lower fuselage to hold periscopes that link to motion capture cameras inside. The Lear 25B flown by Wolfe Air also has a custom pod slung beneath the wing that holds a digital stills camera.

During Learjet photo missions I shoot through the forward-most left and right windows, and occasionally out the windscreen over the pilot's shoulder. Aboard the Wolfe jet, the pod camera also captures the picture plane when it is in trail anywhere from the 4 o'clock to 8 o'clock position.

Throughout the flight the cinematographer and I are constantly talking with the pilot and to coordinate moves and positions. If I am flying with the stills pod, at least eighty percent of the time we are able to shoot simultaneously. There are names for many of the motion sequences, some obvious (tail sweep, orbits, nose cross) and some not (Star Wars, wingtip reveal, and feet wet/feet dry); when I hear one called out, it tells me whether I should jump to a window or grab the pod camera console.

Video likes backlighting and stills like front light, so at times one of us has to stand down until the other finishes his sequence. We make our shot quickly, call "Your plane!" when done, and mark that one off the checklist. Most Learjet flights last under 2.5 hours. The time literally flies by, but it's enough to bring back typically 1,500 stills and 45 minutes of motion footage.

Rutan Model 202 Boomerang

Photographing Burt Rutan's favorite—and wildest—design

Burt Rutan's retirement in 2012 spurred a spate of articles honoring the celebrated aircraft designer's career. He was described as prolific, unconventional, playful, the Mojave Magician, an outlier and a genius. When asked to finally name his favorite project, he didn't hesitate: the wildly asymmetrical Model 202 Boomerang. *Air & Space/Smithsonian* magazine immediately sent me out to photograph it.

Rutan's goal was clear: transform a traditional twin-engine design into an airplane that, if an engine quit in flight, would continue to fly straight without yawing—or flipping over. Beginning with a Beechcraft Baron 58, he moved one engine onto the nose and the second to a small boom. He made the left wing shorter than the right, then swept both of them forward. In the rear, Rutan joined the fins with a horizontal stabilizer that he chopped off outboard of the small boom. The unconventional design worked exactly as predicted. He flew the Boomerang as his personal airplane for six years before signing it over to an engineer who vowed to maintain it.

That's Tres Clements, and he piloted the Boomerang early one morning while chase pilot Chuck Coleman and I flew alongside in Chuck's Baron. It's legal to fly Barons without the rear baggage door, giving a very wide field of view with nothing but air between us. We flew a racetrack pattern west of Mojave over the Tehachapi Mountains. I had calculated the slowest shutter speed needed to create a full propeller circle; as we vectored into the rising sun I made a series of shots bracketed around a $\frac{1}{125}$ shutter speed. The early morning light painted the propellers and Tres with a pleasing golden glow.

Specs: Canon 1Ds Mark III • 70-200mm at 142mm
$\frac{1}{125}$ second, f/5, and ISO 200

Note: This is the most intriguing aircraft I've ever photographed. For more information, find the September 2012 issue of *Air & Space/Smithsonian*.

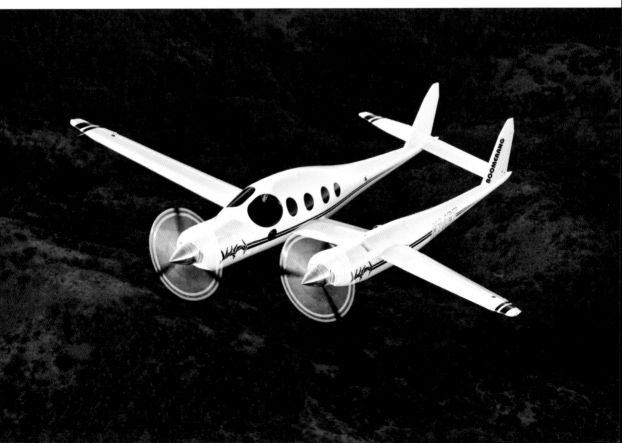

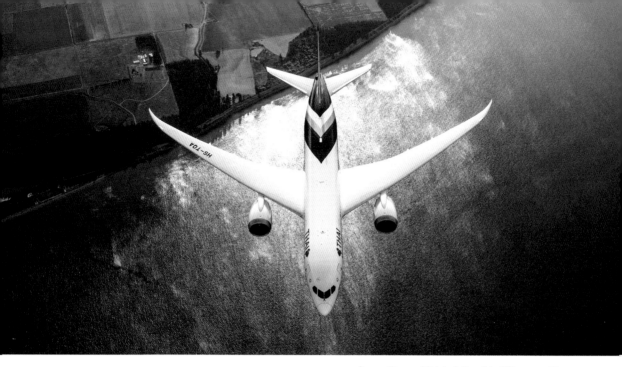

Thai Airways
Boeing 787-8 Dreamliner

Workflow: adjusting raw images in postproduction

Specs: Canon 5D Mark II • 24–105mm at 47mm f/11, ½₀₀ second, and ISO 400

Note: We call crossing from land to water *feet wet*, a phrase US Navy pilots use to signal they've reached open water.

"All photographs are accurate. None of them is the truth." —Richard Avedon

Adobe's Photoshop and Lightroom software give photographers the power to alter photographs in any direction we choose. I take full advantage of that, to show aviation in literally the best light. My workflow begins with Lightroom, lingers in Bridge, and ends with Photoshop, but the sliders in Photoshop's Raw engine are what make the magic.

The process starts by importing all raw files into Lightroom as 1:1 previews. Then I make coffee and read the paper—the import takes a long time. But once done, clicking the 1:1 Navigator option allows fast scrolling through the images to keep the sharp images and delete the bad ones. Now comes the fun.

I open Bridge, navigate to the folder with the images, and by clicking on each image, bring up the Camera Raw processing screen. In this photo, taken with Wolfe Air's underwing stills pod, I added shadow detail +45; brought back highlights –15; increased contrast +30 to pop the white fuselage; and pumped up overall color with +40 vibrance and +40 saturation.

Then I opened the HSL tab to saturate targeted colors: +30 green for the fields; +50 blue for the water; and +15 orange and +24 purple for the stripes. That overexposed the purple stripes; adjusting the purple luminance slider to –50 fixed it. The last step was to mask the white fuselage and wings, then desaturate them to bring back the white paint color. Without apology, the final photograph is both accurate, and untrue.

Rockwell International OV-105 Space Shuttle *Endeavour* on Boeing 747-100 SCA

Networking, zoom telephotos, and luck

NASA's announcement that *Endeavour*, the fifth and last space shuttle orbiter, was awarded to Los Angeles set off a media frenzy. A number of organizations submitted requests to film it from the air during its cross-country flight from the Kennedy Space Center atop the Boeing 747-100 Shuttle Carrier Aircraft (SCA). All were rejected, mine included. Knowing there would be hundreds of photographers, professional and amateur, shooting it from the ground made me decide to simply stay home.

Until Jean Christophe Dick called. JC is a multi-talented photographer whose day job centers on airport design. We had become friends through the years. He is an LAX expert and knew a building whose rooftop would provide a prime spot to photograph the shuttle making a low and slow pass over the airport runway. He was also on friendly terms with a security guard who would unlock the roof's access door. His enthusiasm was contagious. Did I want to sneak up there with him? Of course I did.

The other decision to make: what lens to bring? There would be exactly one pass, maybe 10 seconds long. A map made it clear that the building had a great elevated sight line but was some distance from the airway; a long zoom was the best insurance. I grabbed an image-stabilized 100–400 zoom and a Canon 7D, whose smaller sensor would turn that into the equivalent of a 160–640mm zoom.

As the formation drew near, luck struck. The two chase F/A-18s suddenly accelerated from far behind the 747 to take the lead. I squeezed off three shots; this was the best. A generous friend, careful planning, and dumb luck gave me what only appears to be an air-to-air shot.

Specs: Canon 70D • 100-400mm at 235mm (376mm equivalent) • f/6.3, ⅟₅₀₀₀ second, and ISO 400

Note: I used the HSL adjustments to remove late-afternoon yellow cast and enhance the blue hues, then added a blue sky gradation.

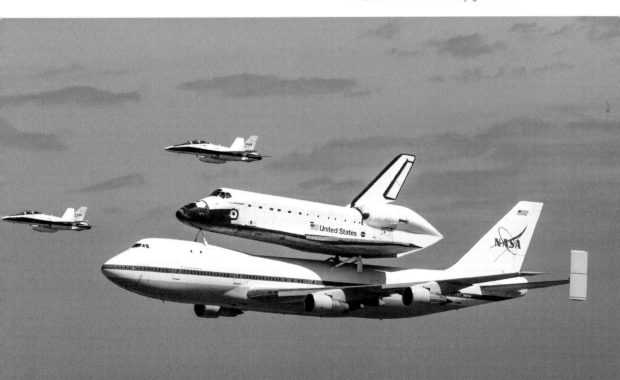

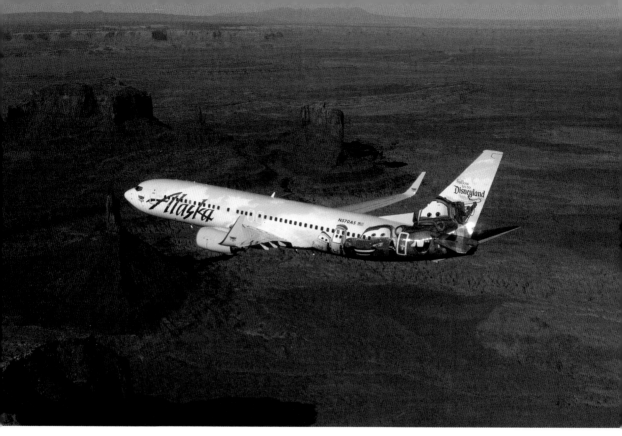

Alaska Airlines 737-800

The right background

Specs: Canon 5D Mark III • 24–105mm at 57mm
f/11, ¼₀₀₀ second, and ISO 1600

Note: A 737 takes off or lands somewhere on the
planet every two seconds; each one has over
600,000 parts

This Boeing 737-800 became the fifth Alaska Airlines jet to carry a Disney-themed livery, celebrating characters from the movie "Cars." A thirty-four-person crew from Associated Painters Inc. worked nonstop for twenty-nine days at Aviation Technical Services in Everett to paint the plane, airbrushing on seventy unique colors, applying more than 10,000 square feet of vinyl graphics and using more than fourteen miles of masking tape.

Since "Cars" is set in the Southwest, Monument Valley was an obvious choice for the backdrop. This image was taken through the front window of Clay Lacy's Astrovision Learjet 25. Alaska needed to press the jet into revenue service; we could not keep it into the very late afternoon when the terrain turns brilliant orange. Postproduction using Photoshop's Raw HSL adjustments replicated the effect.

On air-to-air photo flights, we're looking to position the picture plane against a wide variety of backgrounds: terrain that's attractive but not busy, clouds, ocean, blue sky, snow-capped mountains, and forests. Urban environments are usually cluttered and distracting. Still, clients occasionally request views of their aircraft against a distinctive landmark. Mount Rainier, Lake Powell, Manhattan, Seattle's Space Needle, and the Golden Gate Bridge populate many aerial photographs.

I enhanced this photo by added a gradated blue sky, and removed some glints in the "Alaska" script to maintain the logo's integrity.

Air New Zealand Boeing 787-9 Dreamliner

The importance of shooting huge, raw files

When Air New Zealand took delivery of its first 787-9 Dreamliner, Wolfe Air Aviation was hired to do aerial stills and motion. This shot—we call it a peelaway—was dramatic, but in the original file the jet was too far away, tinted yellow by the low sun, and tilted sharply downward because I hadn't kept the horizon level. Neither airlines nor passengers like seeing Dreamliners plunging towards the sea.

Camera Raw to the rescue. Camera Raw is a plug-in (*i.e.*, software module) built into Photoshop. Files shot in raw format at the time of exposure can be processed in it, and then either shared directly as a JPEG or TIFF file, or opened directly into Photoshop for further tweaking.

I do huge amounts of post processing in Camera Raw. It has a set of powerful editing tools that are easier and faster to use than Photoshop's. And it is non-destructive; like Lightroom, it simply saves a set of editing instructions behind the scenes. At any time, you can return to Camera Raw to undo or modify any setting. The HSL (Hue, Saturation, Luminance) sliders can adjust individual colors, arguably making them the most valuable tool in Photoshop's entire palette.

My camera on this job had a native size of 19x13-inch (5760x3840-pixels at 300ppi). In Camera Raw, the Straighten ruler leveled the horizon. That cost about a third of the pixels, but starting with such a large file, it was affordable. Next, adjusting the HSL sliders removed the yellow cast and saturated the blue ocean. The final photo has clean, rich color—and is still a very versatile 8x12 inches.

Specs: Canon 5D Mark III • 24-105mm at 47mm
¹⁄₁₀₀₀ second, f/11, and ISO 400

Note: The tail fin shows a stylized Maori koru, suggesting an unfolding fern frond; the rear fuselage portrays the New Zealand silver fern.

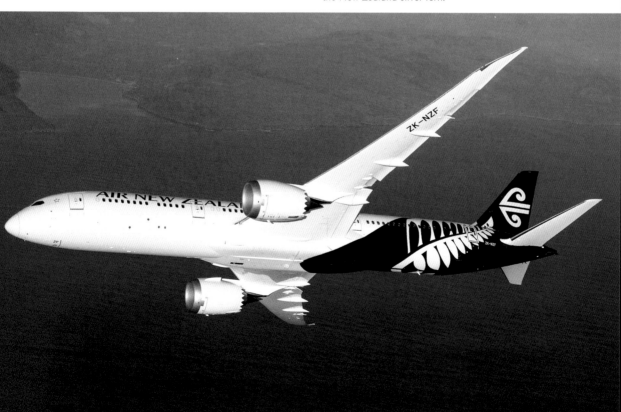

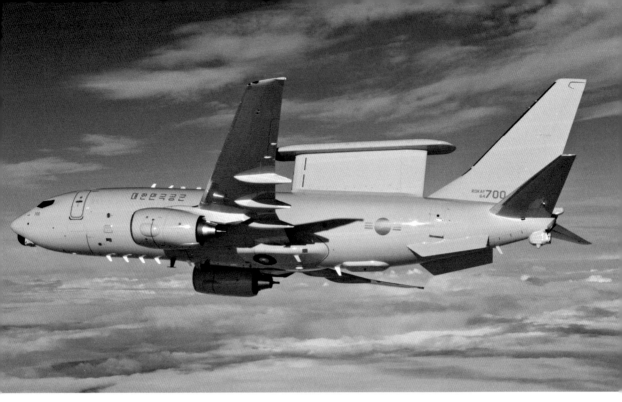

Boeing 737-700 AEW&C Wedgetail

The peelaway maneuever

Specs: Canon 1Ds Mark III • 24-105mm at 67mm
f/13, 1/640 second, and ISO 200

Note: The fast shutter speed and small aperture helped
offset the distortion inherent in shooting through
Plexiglas windows.

Ready for some acronyms? This is Boeing's Wedgetail 737-700 IGW (Increased Gross Weight) Airborne Early Warning & Control (AEW&C) platform, featuring Northrop Grumman's MESA (Multi-role Electronically Scanned Array) radar. It tracks air and sea targets simultaneously using almost three dozen antennae. The fuselage markings are the Republic of Korea's.

The client requested views from all angles to showcase those antennae. This bottom view was popular because it has the rule-of-thirds pleasing composition; has space for overlaying type; shows the aircraft high above the clouds (which also provided fill light); and has top clouds against a postcard-blue sky. Postproduction in Photoshop was simple: the sky got additional saturation and the jet's underside was lightened with the Shadow adjustment.

Clay Lacy's customized Astrovision Learjet was the photo platform for the flight. The 737 has just initiated a peelaway break. In that maneuver, starting a few plane lengths behind us, the picture plane accelerates at the same time the Learjet begins decelerating. On Clay's command "1-2-3-Break!" the 737 began a sharp 30-degree turn, at a rate double what a passenger jet would do with passengers onboard. To the video camera, it appears the picture plane is aggressively turning and climbing. Stills are secondary for this move, but if the lens can grab and track quickly, it's possible to squeeze off a few frames before the two airplanes are too far apart.

Boeing KC-135R Refueling Boeing 737 Wedgetail

Almost a guarantee: 360-degree orbits

On nearly every air-to-air mission I ask our pilots to fly two complete orbits. And if I can get even more 360-degree turns, I take them. Two orbits at a turn angle of 30 degrees in full sun pretty much guarantees you one take-to-the-bank, client-loves-me image. The picture planes are bathed with light from every angle, and fly from that into varying degrees of backlighting. I photograph furiously as we start getting full sun, until the light is hitting right down the centerline. I stop, and the video cameraman spools up as we begin encountering shadow. Stills love sun; video loves shadows.

But the maneuver happens right on the edge of what's called a steep turn. It's not as easy as it looks in the photo below. In even a shallow turn, airplanes will lose speed and altitude without additional power and pilot input. In a steep turn, control becomes challenging. Doing it with another aircraft as a coordinated formation ups the ante. Doing it with two other planes, tenuously connected by a refueling boom, is probably madness.

Unless the two planes are piloted by formation-rated military pilots with multi-engine certificates. During flight test of the Australian Wedgetail AEW&C 737, Boeing took advantage of the in-flight refueling syllabus to make photographs. Flight test is expensive; we weren't given a lot of time to make the requested stills and video. That made orbits the obvious choice. I fired off shots from the right front window of the Learjet, while the cinematographer filmed through the mirrored periscope mounted on the belly. Two orbits, a few straight-and-level shots, and they were gone.

Specs: Canon 1Ds Mark III • 24-105mm at 50mm
¹⁄₄₀₀ second, f/14, and ISO 200

Note: Stills cameras Picture Style settings should be set to "neutral," "flat," or "natural." Adjust color and sharpness in postproduction.

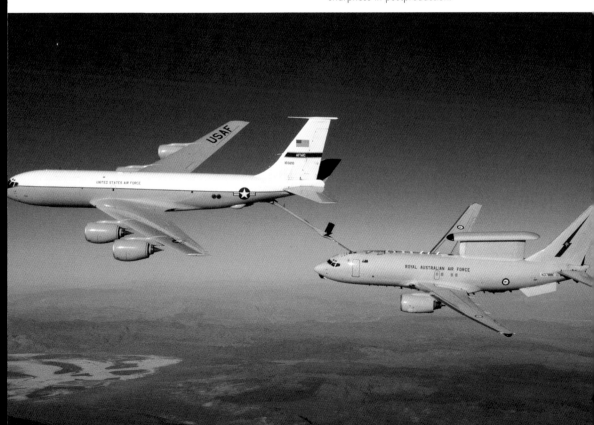

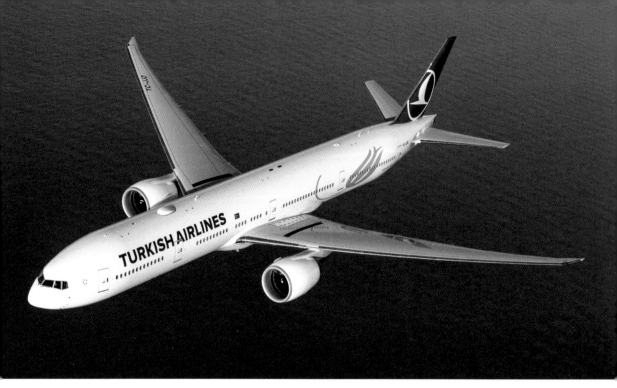

Turkish Airlines Boeing 777-300ER

Photographing aircraft in loose trail

Specs: Canon 5D Mark III • 24-105mm at 73mm f/11, 1/800 second, and ISO 400

Note: A good site for aviation photographers to gain fluency in the language of formation flying is: www.flyfast.org.

Along with the billboard shot, airlines use the ¾ trail photo more than any others. It offers a clean, one-glance look at any aircraft's planform. Against a uniform background like the ocean, it provides room for headlines and copy; it can also be easily silhouetted with photo processing software for insertion into a different background.

Skilled formation flying took form in World War I and matured in WWII. Modern flight demonstration teams like the Blue Angels can fly screamingly fast within three feet of each other; the photo Learjets typically get no closer than 25 feet to a picture plane. Throughout most flights, the picture plane is responsible for navigation and radio duties. The pilot is expected to fly smoothly and announce every upcoming move. We direct the picture plane's heading, altitude, and movements; its primary responsibility is to do what we say. This becomes critically important when flying with airline pilots who never flew formation in the military.

During this flight, we held lead while directing the 777-300ER into a variety of positions as it flew in loose trail (*i.e.*, behind) with us. I asked our pilot to put the airliner at our 5 o'clock low, and he relayed the request to the other pilots. Our heading placed the sun in a perfect position to cleanly light the airline's name and logo. After doing stills for one minute, I called, "Plane's yours!" to the cameraman, who relayed directions that got our Learjet moving smoothly across the 777's nose.

Air China Boeing 747-8

Photographing for the airlines

Boeing's commercial airplane division has been a consistent client for many years. The company sets aside promotional funds when an airline places its first order for a new jet. The airline has several ways to allocate those funds, and many choose to spend them on air-to-air photo flights.

For those missions, it's hard to beat the Learjet 25 as a photo platform. Its cruise and stall speeds closely match those of the airliners we're chasing. The two front windows offer unobstructed profile and ¾ views. The engines are straight turbojets that instantly respond to the throttle: they accelerate quickly and slow down instantly, important attributes when making complex moves close to the picture plane.

Some airlines come to preflight briefs with elaborate storyboards to illustrate angles they

want. Others simply say, "Do what you always do." In either case there are about a dozen still and motion scenarios that the cameraman and I bring back. This shot shows the most important view, nicknamed The Billboard: in one quick glance a viewer sees the airliner's shape, the airline name, and the distinctive tail flash. After this look-down perspective, we'll shoot the plane in profile, then ¾ looking back, then at 4 o'clock high. We favor filming the left side because so many languages read from left to right. Shiny, specular glints are prized too, except when they obscure the airliner's markings.

For a clean look, we always ask the crew to open all the cabin window shades—not an easy undertaking in this 747.

Specs: Canon 5D Mark III • 24-105mm at 47mm
⅟₈₀₀ second, f/11, and ISO 400

Note: Airlines that fly ocean routes want imagery showing their jet going "feet wet" (leaving land) and "feet dry" (leaving the ocean).

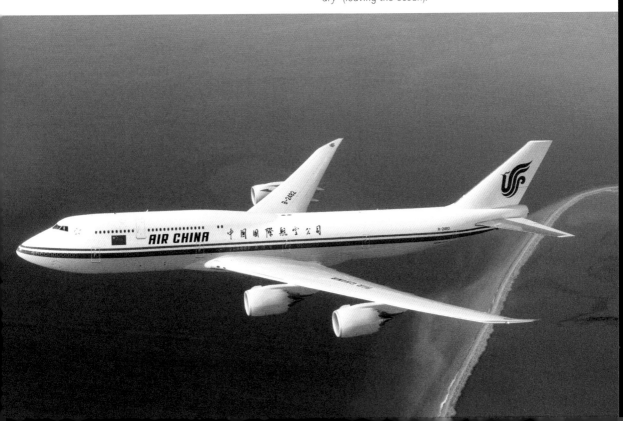

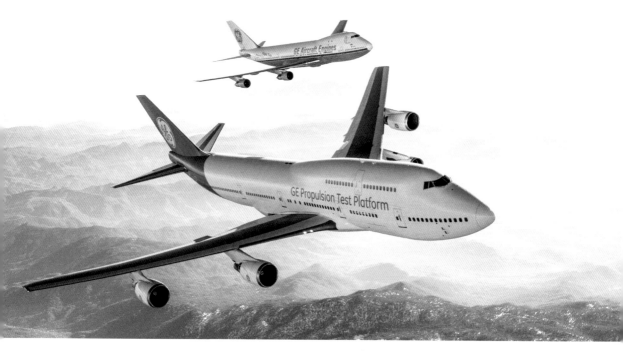

General Electric
Boeing 747-121 and 747-446

Wake turbulence, times two

Specs: Canon 5D Mark III • 24–105mm at 35mm
f/11, 1⁄640 second, and ISO 400

Note: The 747-121 began life in 1970 as N744PA, Pan
Am's Clipper Star of the Union. It is the oldest
747 still flying.

General Electric operates these two 747 derivatives as flying testbeds for new engines. The Wolfe Air team filmed them in rare formation flight one winter day, flying over various California terrains.

The red-striped 747-121 carried GE's then-new Passport 20, while the blue-striped 747-446 is flying GE's LEAP-1A. Both aircraft are heavily modified to support flight test; the 747-446 added almost 900 miles of wiring and fiber optic cable for real-time data analysis.

Our tiny Learjet routinely flies within 25 feet of picture planes many times our size. But two jumbo jets in close formation? How much wake turbulence must that generate? A lot, but pilot/aerial director Kevin LaRosa II avoids it by visualizing two rolling cones flowing into each other

that expand, descend, and then gradually dissipate in intensity. "Directly behind is a no go, and stacked slightly behind and out is also a no go," he explains. "Above is better than below, but I don't ever let our tail touch the cones."

Frankly, this image breaks many rules. The horizon is not level. Despite adding a touch of blue gradation to the sky in post-production, the air still looks hazy. Photographing the right side, and from a ¾ front viewpoint, makes it harder to read the all-important liveries. The aircraft are backlit, adding to the difficulty. And most important, the client's test engines are on the left wing's #2 pylons, completely hidden. I took lots of photos showing them, of course; and despite everything, this photo works.

Japan Airlines
Boeing 787-9 Dreamliner

End of day, low-level light

In the air as on the ground, golden hour is a wonderful time to photograph. Whether front lit or back lit, airliners look especially gorgeous in the last twenty minutes of daylight.

On the return leg of this photo mission we dragged this new 787-9 over the San Juan Islands, in Washington state's northwest corner. At this stage we are usually marking time before filming the landing. But the setting sun, the haze, and the background combined to present a composition that is at once simple and sophisticated. So, despite the extremely low light, I asked our pilot to dedicate a few minutes to just stills and began giving directions.

We adjusted the heading slightly to position the sun perpendicular to the fuselage. The Dreamliner then tucked into a loose trail at our 5 o'clock. The haze turned the sun's last rays into a golden liquid light that gently washed over the fuselage and wings.

If there's little wind and a picture plane's pilot can exactly match the photo plane's speed, there's no relative motion between us. The photograph effectively becomes a 250-knot studio still life. For five minutes, I incrementally zoomed the image-stabilized 24–105 lens from its widest to its longest positions, shooting constantly as the 787-9 flew across the islands. This image, at $\frac{1}{60}$ second with a 24mm focal length at the fixed f/11 aperture, turned out tack sharp.

Specs: Canon 5D Mark III • 24-105mm at 24mm
$\frac{1}{60}$ second, f/11, and ISO 400

Note: Postproduction adjustments included desaturing the jet, then saturating the ocean's orange glow and the tail's red logo.

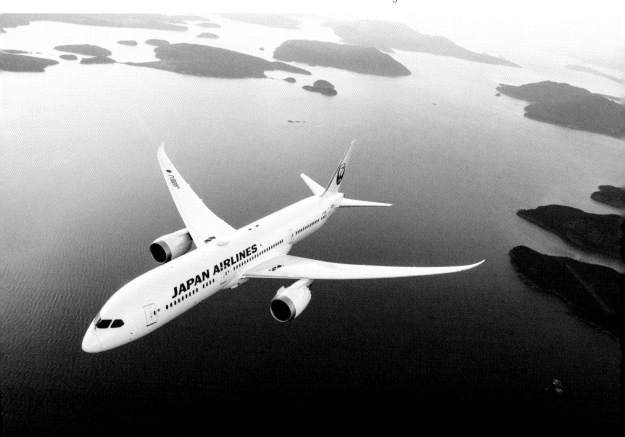

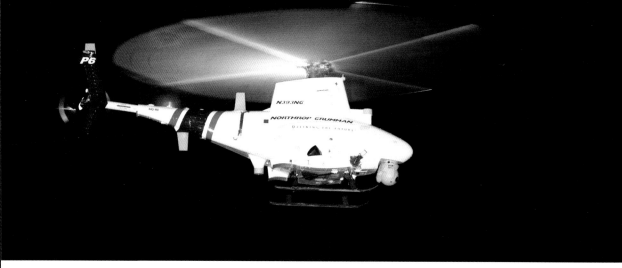

Northrop Grumman MQ-8B Fire Scout

Nightime ground to air, with a portable strobe light

Specs: Canon 1Ds Mark III • 70-200mm at 125mm f/11, 1 second, and ISO 800

Note: Another helicopter definition is: A million parts rapidly rotating around an oil leak waiting for metal fatigue to set in.

Northrop Grumman developed the MQ-8B helicopter to meet a U.S. Navy requirement for an unmanned reconnaissance aircraft able to fly off small ships. A large portion of its flight test was done in a remote corner of Arizona's huge Yuma Proving Ground at night.

Helicopters are hard enough to photograph in daylight. They tend to vibrate a lot (the classic definition of one is "a collection of parts flying in loose formation trying to kill you"). But you can't compensate for that with higher shutter speeds—the blades will look frozen.

Those challenges were magnified on this shoot. There was no ambient light on the helipad to focus by. Range Safety kept all personnel far away. On the plus side, the MQ-8B's white paint was highly reflective. And before

it flew away on its preprogrammed route, it hovered for a few moments a hundred feet high ("on the perch," engineers called it) to dial in telemetry.

I planted my fastest zoom lens, a Canon 70–200 f/2.8, on a tripod. Lighting came from a Norman LH52KR strobe head fitted with the 2H telephoto reflector—it throws a focused beam nearly 5 stops faster than a normal reflector. A 400 watt-second Norman P400B battery pack supplied quick recycling power. As the Fire Scout settled onto the perch, I quickly focused on the letters in autofocus mode with a flashlight, then switched to manual. I bracketed exposures from $\frac{1}{60}$ down to 1 second, aperture wide open. In postproduction a $\frac{1}{60}$ exposure for the aircraft was combined with a 1 second exposure for the rotating blades. The disk colors came from the position lights and rotating beacon.

General Atomics Predator C Avenger

UAV photo flights

General Atomics turned to Clay Lacy for this aerial shoot, shortly after introducing this jet-powered successor to the company's wildly successful prop-driven Predator B. The Avenger's size, speed, and range allow fast transit to an observation orbit, and longer loiter time once there. Unlike its predecessor, Avenger incorporates stealthy design features to reduce radar returns. But it has no pilot onboard.

"Boys, this thing doesn't know any fear." Clay's opening remark at the preflight brief set the tone. Its pilot would be many miles away, in a trailer. His only way of getting a visual on our Learjet would be through a video camera in the Avenger's chin turret, under the fuselage. Anytime we rose above the horizon, he would lose us. Regardless, the customer wanted the same complete visual coverage—video and stills—as if its jet had a cockpit with a pilot in it.

Clay and the Avenger pilot responded to the challenge by planning exact routes and a timetable, based on racecourse patterns that General Atomics had run hundreds of times with the Predator B. The picture plane would set a heading for a given amount of time; Clay would then maneuver the Lear around the Avenger to find the best light and angles. We were then able to make the same imagery as if we were photographing an airliner.

I shot this image through the bottom port periscope normally used by the video camera. The tube has some limitations for stills, but postproduction can correct many of them.

Specs: Nikon D700 • Astrovision Periscope lens ½₀₀₀ second, f/16, and ISO 3200

Note: The periscope has a strong yellow cast, a maximum aperture of f/8, and best sharpness at f/16; images needed extensive adjustment in postproduction.

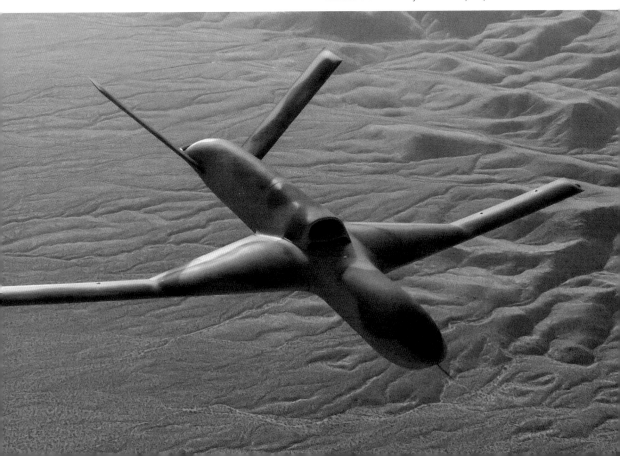

Embraer Legacy 650

The photo mission briefing

At minimum, every pre-flight brief should cover the items in this list.

1. Names and duties of everyone on each aircraft
2. Mission goals and duration
3. Lead exchange protocols
4. Times for step to planes, engine turns, and liftoffs
5. Pilots' cell phone numbers for last-minute changes
6. Rendezvous procedures if filing separate
7. call signs, and assignment of responsibility for primary navs and comms—usually the picture plane's
8. Primary and backup radio frequencies;
9. After joinup, initial formation speed that is slow enough to conserve fuel but fast enough to keep target aircraft's control surfaces in clean configuration
10. Weather conditions, especially cloud tops
11. Protocol if visual contact is lost
12. Protocol if radio communication is lost
13. Knock-it-off (termination of formation flying) conditions and procedures
14. Formation terms, such as, ramping, sliding, stacking down, peelaways, flyaways, rise-ups, nose and tail crosses, and stepping down
15. special considerations when filming a break;
16. Orbit bank angles
17. picture plane lights and strobes on or off —best to begin with all on, then switch off as necessary
18. Reminder to picture plane pilots to dress appropriately and keep hands off glare shield
19. Reminder that all picture plane window shades should be open
20. Check for TFRs (Temporary Flight Restrictions), "hot" MOAs (Military Operations Area), or borders that must be avoided
21. Procedures for filming takeoffs and/or landings.

Aerial Director Kevin LaRosa II ends his briefs with this note: "At day's end, it's all about taking great images, and making the aircraft look amazing. But the primary responsibility is safety: bringing both planes back home. Everything else is just fun."

Specs: Canon 5D Mark II • 24-105mm at 40mm f/11, 1/125 second, and ISO 100

Note: This close shot developed at the end of the day's second flight, after pilots on both planes had learned to trust the other's flying.

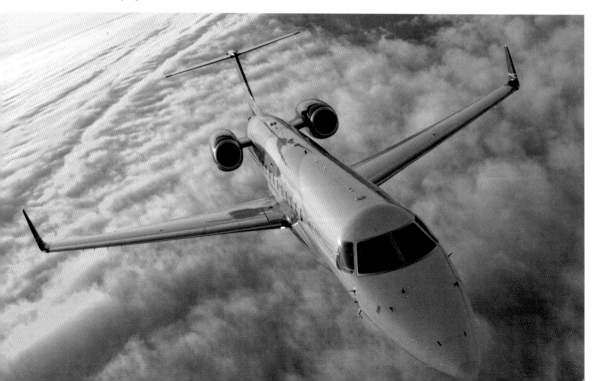

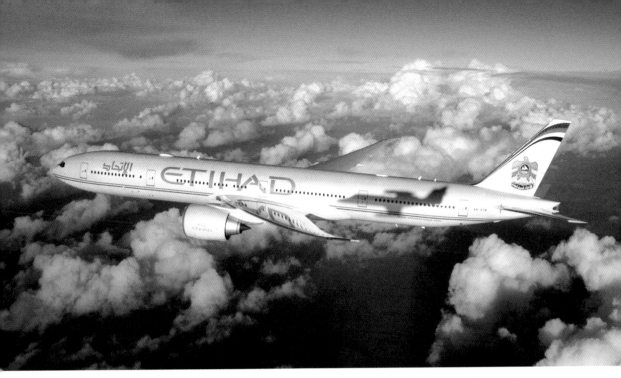

Etihad Airways
Boeing 777-300ER

A hitchhiker's guide to the photo Learjet

Specs: Canon 1Ds Mark II • 24-105mm at 24mm
1/200 second, f/14, and ISO 100

Note: The Learjet's shadow shows its size relative
to the 777. Our low flights had spurred calls
to local TV stations reporting that a fighter
intercepted an airliner.

Congratulations! Your new 777-300ER cost over a third of a billion dollars, but comes with a perk that few mortals will ever experience: a seat on our highly modified Learjet 25B during the photo flight. You stayed awake through the pilots' detailed preflight brief, and have strapped into the rear bench seat alongside the cameraman and his control console. Hopefully, you drank very little of anything today and made a last restroom stop—our tiny jet has no facilities.

Up front sits the pilot/aerial director and the copilot; behind them sits the stills cameraman. He's positioned to photograph out either of the front windows, or to grab the console that remotely controls a high-resolution digital camera underneath the wing. The digital tech rides alongside, monitoring all video input for signs of technical glitches.

Takeoff acceleration is ludicrously fast, quickly pinning you to the seatback. You're patched into the intercom and hear aviation's clipped, terse lingo crackling nonstop between us, the picture plane, and air traffic control. Inside the Lear, the cameraman is an aerial quarterback calling plays. You'll hear him say "nose cross," and watch the stills guy swivel from the window, put down his camera, and grab the console. "Nose cross" tells everyone aboard exactly where the next move will start and stop.

For the next two hours you'll watch two crews in two planes weave, slide, and turn so close, and so choreographed, that by flight's end you'll swear you saw an aerial ballet.

Fairchild Republic
A-10 Thunderbolt II

Adding punch with color and lighting

In those prehistoric times when magazine photographers shot film and billed for long distance calls, *Air & Space/Smithsonian* magazine sent me to Georgia for a cover story on the A-10 attack jets flying out of Moody Air Force Base. It's a brute of an airplane, well deserving of its nickname: the Warthog.

I imagined this dusk photograph long before making it, and packed a Nikon 300mm f/2.8 (itself a brute). Using a Bogen Superclamp and short Leica Leitz 14119 ballhead, I attached a Nikon SB-24 under the cockpit's glare shield, counting on the uplighting to accentuate the menacing stare of the pilot wearing his night vision goggles. The hot glow surrounding the nose cannon came from a Norman 200B portable strobe, fitted with a deep red gel and positioned below the gun, just out of camera sight. It and the SB-24 were triggered remotely using PocketWizard Classic radios.

What I didn't imagine was the garish ramp lighting that bathed the jet in greeen when they flickered on at dusk. The solution in film days was simple—fit a CC30M gel over the lens and CC30G green gels over the two strobes—but when I did it, the plane looked boring.

So the filters came off. I quickly made several dozen shots, varying the ratio of strobes to the ambient green ramp light. As the sky deepened into a rich magenta, the red and green popped against it. What I had first loathed, I now loved.

Specs: Nikon F5 • Nikkor 300mm f/2.8
Fujichrome Velvia 100 (film)
f/11, 2 seconds, and ISO 100

Note: The A-10 cannon shells are nearly a foot long, with a uranium core designed to penetrate tank armor. Firing rate is 3900 rounds per minute.

Northrop Grumman X-47B

Including people to add scale

Including crew members in aircraft ground shots offers several advantages:

1. It adds immediate scale to the image;

2. Their presence says: this aircraft is not a model;

3. It's a chance to add a bit of color when the picture plane is a drab low-vis gray;

4. And most important, the crew become active partners in creating the photograph, with a corresponding increase in helpfulness and (occasionally) inclination to bend the rules.

Like a number of images in this book, this shot of Northrop Grumman's unmanned X-47B was made while on assignment for *Air & Space/Smithsonian* magazine, at the secretive Air Force Plant 42 in Palmdale. (To gain access, photographers must permit company and Air Force security teams to review all images. Examining wider views that included distant hangars, the lead pointed to one building across the runway. "Remove this," he said, "It's not there.")

From a scissor lift, I directed placement of the aircraft first, and then the technicians. The late afternoon sky had patches of high cloud cover that let direct rays through, but also bounced lots of soft fill light on the jet. In postproduction I smoothed over rough patches on the ramp, added saturation to the yellow markings, and retouched out one proprietary feature visible only from this angle.

Specs: Canon 1Ds Mark III • 24–105mm at 28mm
⅟₃₂₀ second, f/4.5, and ISO 100

Note: A RRS BH-40 ballhead and Manfrotto 458B tripod were used on the lift to ensure crisp focus, sharpness, and precise composition.

Convair B-58 Hustler

Photographing from a high snorkel lift

Air & Space/Smithsonian magazine requested a cover photograph for an issue featuring Convair's long-retired Mach 2 B-58 Hustler. The bomber's planform would work perfectly for a look-down vertical shot. But shooting from an overhead helicopter would have kicked up a dust storm, and it's almost impossible to avoid a chopper's skids when looking straight down. The solution was a 120-foot high snorkel lift, cranked to put me directly overhead. A passing thin cloud provided light soft enough to erase shadows, but specular enough to make the polished aluminum gleam.

Specs: Cannon 1Ds Mark II • 24-105mm at 24mm f/6.3, 1/125 second, and ISO 100

Note: This B-58 belongs to the Pima Air & Space Museum in Tucson. When told it would be on the cover, volunteers worked for three weeks to polish the aircraft. The worker atop the wing suggests the bomber's scale. For my own safety, I tethered myself to the lift's bucket, and the camera to my harness.

Douglas A-4N Skyhawk

Some postproduction suggestions

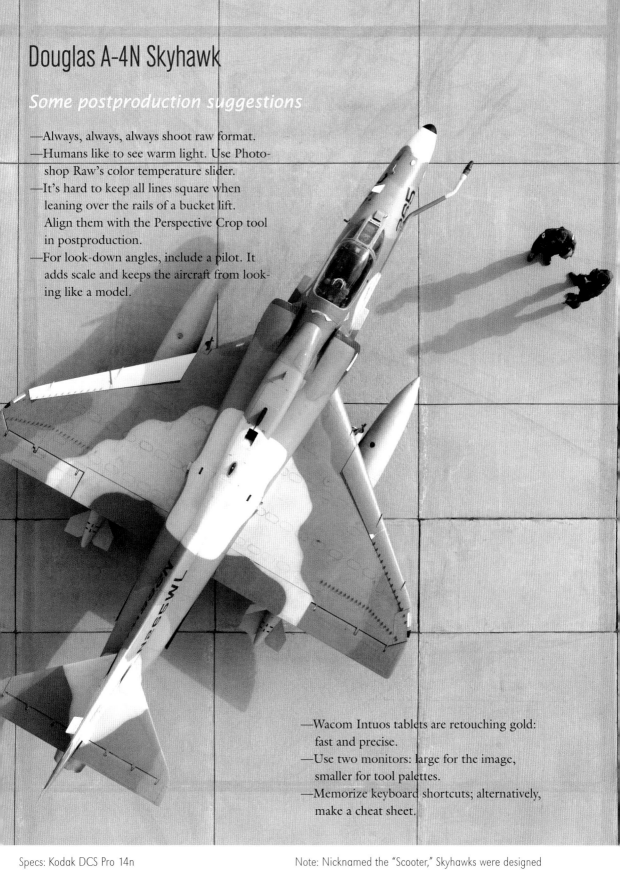

—Always, always, always shoot raw format.
—Humans like to see warm light. Use Photoshop Raw's color temperature slider.
—It's hard to keep all lines square when leaning over the rails of a bucket lift. Align them with the Perspective Crop tool in postproduction.
—For look-down angles, include a pilot. It adds scale and keeps the aircraft from looking like a model.

—Wacom Intuos tablets are retouching gold: fast and precise.
—Use two monitors: large for the image, smaller for tool palettes.
—Memorize keyboard shortcuts; alternatively, make a cheat sheet.

Specs: Kodak DCS Pro 14n
Nikkor 24-120mm at 30mm
1/250 second, f/8, and ISO 100

Note: Nicknamed the "Scooter," Skyhawks were designed to launch from aircraft carriers and drop an atomic weapon.

Boeing B-17G Bomber Gas

Correcting green fluorescent light with magenta filtration

For forty-three years, this B-17G Flying Fortress flew top cover for 48 pumps at Oregon's "Bomber Gas," dispensing more fuel during the 1960s than any other station in the U.S. Fledgling pilot Art Lacey bought it in 1947 for $13,750, then flew it from an Oklahoma storage yard to its eventual home in Milwaukie, Oregon. It was a terrific advertising gimmick, and Bomber Gas became a world-famous landmark.

But in 1991 Lacey shifted his focus from selling gas to selling Bomber Burgers from the property's restaurant. Following his death in 2000, the B-17G fell victim to corrosion, nesting birds, Oregon's harsh winters, and occasional vandalism. Finally, in 2016, the aircraft was dismantled and trucked to nearby Aurora. Now named "Lady Lacey," efforts are well underway to restore it and preserve it.

This photo was made in 1985. It began my "Grounded" portfolio, a personal project documenting re-purposed aircraft that would never fly again. On a whim I used my then-new Nikkor 35mm perspective control lens. It was the first time I ever thought to treat an airplane as architecture. I was too new to afford a Minolta color meter, but had photographed enough commercial buildings to know that the station's lights would turn my Kodachrome 25 a sickly green. Adding a CC30M magenta filter fixed that. And the deep purple sky? Gregory Heisler, the great American portrait photographer, teaches in his workshops that as long as there's one tiny island of believable color in the photo, you can get away with color murder in the rest of the frame. Here, the white car buys that credibility.

Specs: Nikon F3 • Nikkor AiS 35mm/2.8 PC
Kodachrome 25 (film)
8 seconds, f/5.6, and ISO 25

Note: This B-17G's 1947 wild journey from Oklahoma storage to Oregon gas station is well worth reading about; use a search engine to look up: Lacey's Lady.

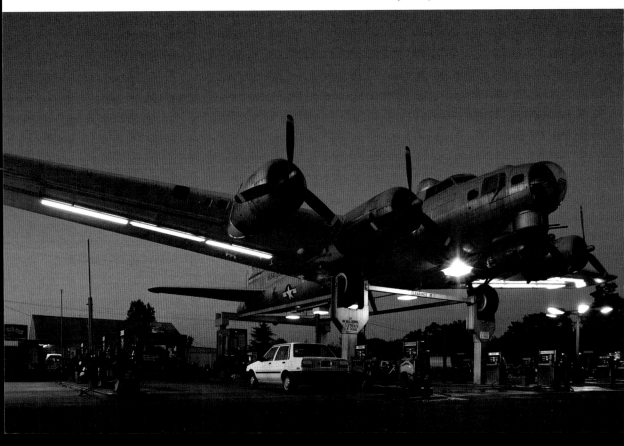

Specs: Nikon F4 • 35–70mm at 70mm • Fujichrome Velvia (film) • $1/500$ second, f/5.6, and ISO 50

Note: Each scrapped B-52 yielded thirty tons of recycled aluminum and other metals.

Boeing B-52 Stratofortress

Military aero clubs are your friends

Under the 1991 Strategic Arms Reduction Treaty, the U.S. and U.S.S.R. agreed to destroy hundreds of their strategic bombers. Over the course of seven years, three hundred sixty-five B-52s flew into Arizona's Aerospace Maintenance and Regeneration Center (AMARC then, AMARG now) on their last flights. Crews removed usable components, then cut the jet into four pieces. Before scrapping, the ruined bombers sat in place for three months so Russian satellites could confirm their destruction.

I was assigned to make an aerial photo that would mimic what orbiting Soviet spy satellites saw. AMARG sits inside the very active Davis-Monthan military base; I quickly discovered that civilian pilots are just about never permitted to loiter over the area. But while scanning the base phone directory in search of a sympathetic commanding officer with waiver powers, "Aero Club" popped out. Like many USAF bases, Davis-Monthan hosted a flying club that offered military members inexpensive flying lessons and rental planes. Through the club I found an Air Force pilot who agreed to fly me— and who was of course permitted to fly in AMARG airspace.

We launched late on a December afternoon in the club's Beech T-34A. It's a tandem trainer with canopies that slide straight back, providing an almost perfect look-down view from the back seat with nothing but air to shoot through. The pilot got clearance, navigated over to the B-52 boneyard, and proceeded to stand that little airplane on its left wing in the tightest circles I've ever flown. I just leaned over, looked straight down, and kept punching the shutter release.

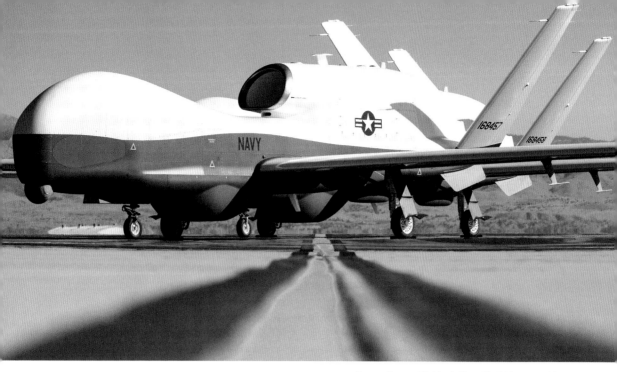

Northrop Grumman MQ-4C Triton

Taking the low road: explore every angle

Specs: Canon 5D Mark III • 70–200mm at 200mm f/8, 1/400 second, and ISO 100

Note: Triton boasts 24 hours unrefueled endurance and an 8,100 mile range; its sensors can image 2,000 square miles in one sweep.

Early in my career, I took a UCLA photojournalism class from Los Angeles Times photo editor Wayne Kelly. He hammered us to always view subjects from every angle; to walk a full circle around them; to grab a ladder or a bucket lift for an overhead perspective; and to get low for a bug's-eye view.

That training kicked in when Northrop Grumman gave me three hours to photograph two of its new unmanned MQ-4C maritime surveillance jets together. Like its cousin the Global Hawk, the Triton's combination of a short fuselage and long skinny wings presents a real challenge. Playing with two models helped me previsualize camera placements that would squeeze both aircraft into the Canon 5D Mark III's 3:2 full-frame ratio.

For the late afternoon shots, the line crew used my crude sketch to position the two aircraft at an angle to the taxiway, but parallel to each other. I spent an hour circling them on foot and on a scissor lift, alternating between wide and telephoto zoom lenses. This frame was made with the zoom racked full out to 200mm; the f/8 aperture kept letters and numbers sharp while letting foreground and background go pleasingly soft. The combination of selective focus and the dramatic yellow striping direct the viewer's eye quickly to the jets.

The low camera angle, six inches off the ground, dramatizes the aircraft. More importantly to the client, it emphasizes design features like the sensor bulges, and the engine intake positioned to minimize radar returns.

Northrop Grumman MQ-4C Triton

Composing and lighting a two-aircraft shot

The MQ-4C photo on the preceding page showcased the sensors, but not the long, high aspect ratio wings central to the jet's endurance. As dusk approached, crew members positioned the scissor lift. I climbed on and rode up to its maximum 40-foot height. From there it was easy to direct aircraft placement. A zoom lens set to 24mm filled the frame with both aircraft.

The rear jet was perfect just where it stood; its main purpose is to delineate Triton's sailplane-like configuration. The crew hooked up the front aircraft and in remarkably short time aligned it perfectly with the yellow stripe. Its wings were cropped by the 24mm focal length but because the rear jet showed its entire wingspan, the clipping was of little importance.

As the sun descended I shouted down orders for placing three battery-powered Norman 400B strobe lights on the ground: two illuminating the leading edge of the front aircraft's wings and one pointing down at the rear aircraft's left fuselage. A fourth Norman strobe was mounted on the lift just below my tripod, to skim light across the top of the forward aircraft's fuselage and into its engine inlet. PocketWizard Plus III radio remotes triggered all four lights.

To make the dusk shot look as close to natural light as possible, I began with a no-strobe, $\frac{1}{30}$ second exposure, then bracketed through 8 seconds. The 2-second exposure was perfect but the light was flat. I switched on the strobes and made bracketed exposures by varying the aperture from f/4 through f/16. The final setting of 1 second at f/8 perfectly balanced the strobe light with dusk light.

Specs: Canon 5D Mark III • 24-105mm at 24mm
1 second, f/8, and ISO 400

Note: The day after this shot, my voice trashed from shouting directions for an hour, I bought a battery-operated megaphone.

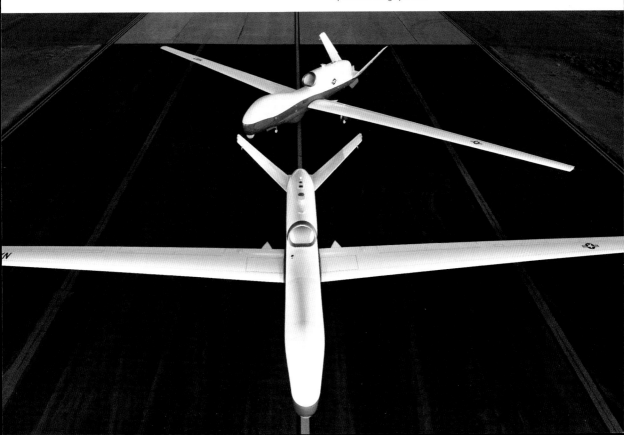

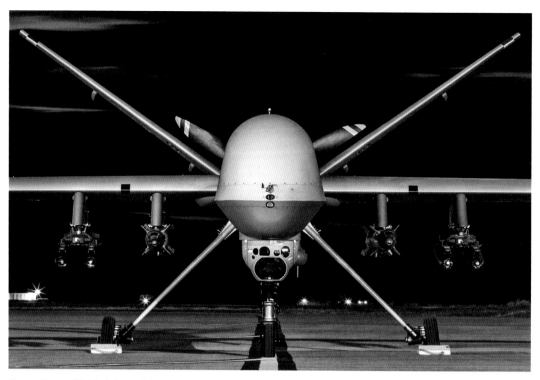

Specs: Canon 5D Mark III • 100-400mm at 280mm
f/16, 30 seconds, and ISO 100

Note: A pox on chocks! They link a viewer's
imagination to the ground, not to the skies. But
the USAF crew insisted they stay.

General Atomics MQ-9B Reaper

Aircraft portraits with long telephoto lenses

Looking like bazookas, mega-telephoto lenses
are ubiquitous at airshows, and outside the
fence at air bases. They give enthusiasts the
power to reach out, filling the frame with their
favorite aircraft. Some professionals dismiss
these photographers as "tailspotters," but it
takes constant practice and a steady hand to
acquire and track fighter jets screaming past
at 500 mph.

Those same lenses are equally powerful
when photographing aircraft on the ground.
Photojournalist Mark Meyer pioneered that
use in *Wings*, his seminal 1984 book on U.S.
Air Force jets. He used 300mm and 400mm
telephoto views to distill the fleet's muscular
lines and sharp edges into sculptured speed. His
influence can be felt throughout my own work.

So when a chance arose to photograph a
Reaper unmanned aerial vehicle at Holloman
Air Force Base, Canon's 100–400mm zoom
lens was first into the bag. I began the shoot by
setting battery-powered Norman 400B strobes
at the nose's 2 and 10 o'clock positions. As
the sky darkened, I slowly backed away from
the aircraft, looking through the camera. With
the focal length just under 300mm, everything
worked: sharp chin turret, all propeller blades
visible, and clean aircraft mold lines.

The final exposure was 30 seconds, a
mixture of the yellow ramp ambient light with
four radio-triggered pops of the strobes at full
power. In postproduction I masked the Reaper
and desaturated the yellow cast from it to re-
capture the aircraft's true gray color.

Northrop Grumman
MQ-8C Fire Scout

Rethinking the crew shot

For as long as there have been cameras, workers and projects, there have been crew shots. This group of Northrop Grumman engineers was closing out a challenging phase of the unmanned MQ-8C's flight test program; they wanted a group photograph to commemorate the milestone. Standard protocol is to line everyone up in front of the aircraft outdoors on a ramp, hope not too many people squint or close their eyes, and fire off a quick burst at ground level.

But I had control of the helicopter, with access to a hangar and an hour to set up. It provided the perfect opportunity to try something different. Or to fail gloriously in the process.

The crew chief wheeled the Fire Scout in. At my request, he left the hangar doors open to splash in some backlighting, and rotated the four main rotor blades for perfect symmetry. Beneath the fuselage, I set up two ancient Nikon SB-26 shoe mount flashes, triggered by PocketWizard Flex TT5 radio transceivers. Both flashes had turquoise gels taped on—a subliminal nod to the MQ-8C's mission of maritime surveillance. Next came four Paul Buff AlienBees B1600 strobe lights, triggered by PocketWizard Plus III transceivers. Even in the digital age, I carry a Sekonic L-358 ambient/flash meter, fitted with an optional chip that remotely triggers PocketWizard transceivers. I used it to space the AlienBees so they would light both the helicopter and the crew evenly.

The hangar had a indoor balcony that made a perfect perch for shooting. As the crew members came in they lined up with the rotors. I made five shots, checked the LED screen for blinks, and we were done.

Specs: Canon 5D Mark III • 24-105mm at 24mm
1/13 second, f/9, and ISO 100

Note: Hindsight department: the shot would be a bit stronger if I had lined the crew on the aircraft's left side like on its right, and varied their poses.

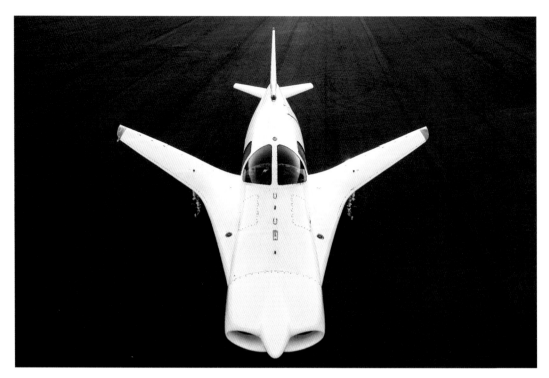

duPont Aerospace DP-1C

Ugly jet, beautiful light

Specs: Canon 1Ds Mark III • 24–105mm at 24mm
⅟₃₀ second, f/8, and ISO 100

Note: Tony duPont's previous studies for the classified Copper Canyon hypersonic program became the baseline X-30/NASP design.

Never stop proposing ideas to aviation magazines. If you are a newcomer with an unusual story angle plus a portfolio that promises the ability to develop a complete article, editors are likely to take a chance on you. If you are already an established contributor, your suggestions get immediate, serious consideration.

On a portrait assignment at California's Ramona Airport, I spotted this DP-1C sitting forlornly in a remote corner. It was possibly the ugliest airplane ever built: I got curious. The backstory proved fascinating. The jet was pitched as a VTOL technology demonstrator to explore vectored thrust. But every aeronautical agency that reviewed the program, argued for its cancellation. Nevertheless, concurrent with well-timed contributions to their campaigns, local Congressmen ramrodded through annual funding that eventually totaled $63 million— with never a successful flight to show for it.

Congressional hearings followed, designer Tony duPont delivered an impassioned defense of the plane's aeronautical promise, agencies again underscored its deficiencies, and in short order the program quietly died.

It was a great story: politics, scandal, technological breakthroughs, aerodynamic theory, conflict, lots of money, and ultimate failure. *Air & Space/Smithsonian* magazine agreed, commissioning what became a two-page article I wrote and photographed. This was the lead photo. The wide angle lens emphasized the odd jet's stubby nose and awkwardly placed (but gracefully swept) supercritical airfoils. Late afternoon sun painted the awkward jet with a dissonant backlighted softness that did little to hide its ungainly lines.

Gates Learjet 25B

No lift? Use the hangar roof

Because top views of aircraft are rare, they grab viewer attention. This still was made as part of a film project showcasing Wolfe Air's aerial capabilities. The Lear's sleek lines lent themselves to a top view, and the director decided to shoot looking straight down as it rolled out from the hangar.

The hangar had a sturdy roof and importantly, an outside hand-over-hand ladder cage offering access. I carried up the tripod, a Canon 5D Mark III (because it shoots both video and stills), and an electronic cable release. Next trip, I hauled up a Manfrotto 131D lateral side arm; by mounting it on a tripod's center post and attaching a Really Right Stuff BH40 to the end, it was possible to slide a camera over the hanger's roof to shoot down without seeing tripod legs. On the third and seemingly longest climb, I brought a twenty-pound shot bag to counterbalance the side arm.

The magic hour filming went great. As dusk turned a little too dark for motion, it was time to switch the 5D to stills. Light from the open sky acted like a huge softbox with just enough contrast to pop the Learjet 25B's engine mounts and shiny noise supressors.

But the plane's dark gray paint that looks so wicked in daytime, turns a bit mushy in shade. Happily, late dusk sky naturally paints everything with cold blue hues. That seemed license enough to re-set the camera color temperature from Automatic White Balance (AWB) to 3200 degrees Kelvin. Every other color—the tug's red, the vest's neon green, the line guy's face—looks natural, so the jet does. As previously mentioned, the eye needs just one realistic color anchoring a scene to make it all believable.

Specs: Canon 5D Mark III • 24-105mm at 28mm
⅙ second, f/4, and ISO 200

Note: Bill Lear was 61 when he began developing the Learjet; he had invented the first jet autopilot, but had never designed an airplane.

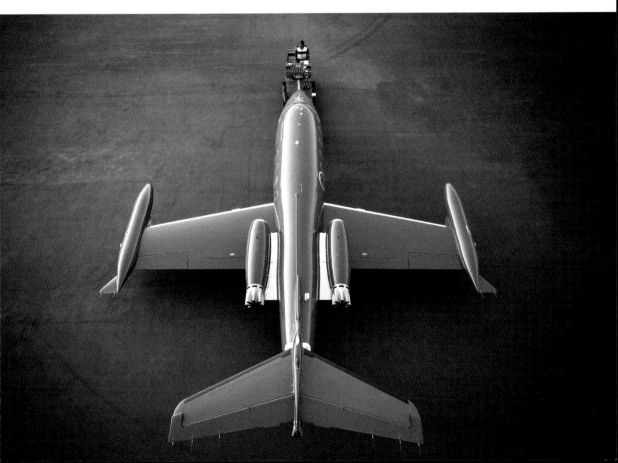

Fleet Shot I

Choreographing airplanes on the ground

Specs: Canon ESO 1Ds Mark III • 24–105mm at 50mm
¹⁄₁₆₀₀ second, f/4, and ISO 100

Note: It took eleven hours of postproduction to retouch out oil stains and equipment clutter from the ramp.

Clay Lacy Aviation is one of the nation's oldest and most respected all-jet operations. Clay began the company's charter operations in 1968 with one leased Learjet and three pilots; for many years after, various Lear models were the company's backbone. But four decades later, his fleet had evolved to favor mid-size Challenger and long-range Gulfstream jets. To show this, Clay requested an elevated view of as many jets as we could fit on his ramp at Van Nuys Airport in California.

The obvious photo platform was a helicopter. Orbic Air operated a Robinson R44 on the field and sold us a 30 minute flight, agreeing to remove a door to permit an unobstructed view. A pre-shoot ground survey pointed to 5PM as the best time to have the February sun low enough for good light, but high enough to prevent aircraft shadows from falling onto each other.

Adam Elzinga's line crew began by towing eight jets to ramps adjoining the taxiway, where they could be easily accessed. The two large Gulfstreams were positioned first, at 45-degree angles at the top of the frame, followed by a Challenger between them. A Falcon and Gulfstream 150 were stacked in front of the Challenger's nose to complete the center line. At that point I took to the air and used a transceiver to direct placement of the remaining six aircraft flanking the center line. Clay was clear: do not fly more than the 30 minutes he had budgeted. At the 25 minute mark the planes were not perfectly symmetrical, but were close enough. I shot for three minutes, and we landed with one minute to spare on the clock. Today this shot hangs in Lacy's hangar restrooms; I'm not sure what that means.

Fleet Shot II

Architecture meets aviation: photographing an FBO

It's a bit ironic that a photographer (yours truly) who uses architectural perspective-control lenses to photograph jets would choose a zoom lens to photograph architecture. I had brought both types of optics to this shoot for Camarillo, CA-based FBO Sun Air Jets. FBO stands for fixed base operator; you'll find them at nearly every airport, selling fuel and providing other aircraft-related services.

Besides the FBO, Sun Air also operates a charter jet service out of its ultra-modern facility. Marketing wanted one hero shot showcasing both the building and the fleet.

The line crew first hid all the usual ramp stuff: cones, chocks, fire bottles, tugs and carts. They parked my scissor lift at the taxiway's red line. I chose a 17–40mm zoom lens because its electronic focus and exposure features, along with multiple focal length choices, would make it faster to use in the critical twenty minutes of post-sunset golden light than a manual perspective control lens. I leveled it and began directing placement of the jets, starting with the big Global 6000 in the rear and working towards the smallest jet up front. Each plane was positioned as close as possible to the next, with wingtips almost touching, and the noses aligned to the same concrete score line. Sun Air initially wanted the prestigious Global up front, but its enormous size would have obscured all the other aircraft.

As dusk descended, I leveled the tripod and camera, chose a 35mm focal length, and then locked everything down. For the next twenty minutes I shot dozens of frames at f/8, varying shutter speeds as light levels lowered. I combined elements from many frames to make this final image in postproduction.

Specs: Canon EOS 1Ds Mark III • 17–40mm at 35mm ¼ second, f/8, and ISO 100

Note: In postproduction, I warmed the color temperature, brightened the signs, removed ramp oil stains, and added color to the sky.

All Nippon Airways Boeing 787-9 Dreamliner

Photographing from a helicopter

On assignment for Boeing, I flew with the video cameraman over, alongside, and straight towards this new 787-9 while it taxied and then departed. Whether you're a stills photographer or an aerial director, a helicopter is the ultimate camera dolly. They're expensive, but if you can fly with the door off, they offer rapid response, fluidity, and versatility. Here are some things for stills shooters to remember:

— Space and time are at a premium. Forget changing lenses or cards; it takes too much time and invites dust on your sensor. Instead, take two cameras, one with a 24–105mm zoom and one with a 100–400mm zoom. Use the largest-capacity memory cards your cameras can accommodate.

— Secure your cameras. Attach one end of a very long climbing-grade daisy chain (I use Metolius products) to a seat anchor with a climbing-grade locking carabiner. Thread the chain through the seat bottom and attach it to your camera strap with another carabiner. If you do this with both cameras, you can leave one on the seat but quickly and safely switch between them.

— Don't fall out. Wear a climbing harness (Metolius Safe Techs are light and strong). Attach it to a seat anchor the same way you did the camera, with a daisy chain and locking carabiner.

— Additionally, wear the seat belt. Loose is OK, but secure the buckle with a swatch of tape that's strong enough to prevent accidental unlocking, yet weak enough to let you quickly rip through it in an emergency landing.

— If you tilt your camera too much skyward, beware the rotor blade showing up in your photo. To your eye the rotor disk is almost invisible, but a fast shutter speed will show it clearly. And leave your lens caps home.

— Never use a lens shade. If it falls off, it's a hazard; if you lean too far out, it becomes an instant sail.

— No matter the ground temperature, bring a jacket and watch cap. With doors off, it can get cold fast.

Specs: Canon 5D Mark III • 24-105mm at 58mm $\frac{1}{2000}$ second, f/10, and ISO 400

Note: AOPA Senior Photographer Mike Fizer jokes that the best safety measure in a helicopter is attaching your tether to the pilot's ankle.

Mojave Air & Spaceport

How to photograph 34 aircraft at once

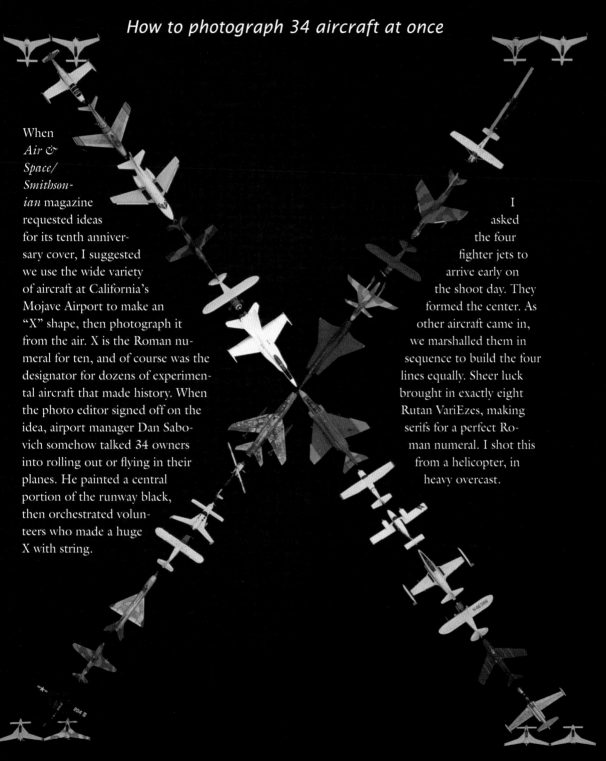

When *Air & Space/ Smithsonian* magazine requested ideas for its tenth anniversary cover, I suggested we use the wide variety of aircraft at California's Mojave Airport to make an "X" shape, then photograph it from the air. X is the Roman numeral for ten, and of course was the designator for dozens of experimental aircraft that made history. When the photo editor signed off on the idea, airport manager Dan Sabovich somehow talked 34 owners into rolling out or flying in their planes. He painted a central portion of the runway black, then orchestrated volunteers who made a huge X with string.

I asked the four fighter jets to arrive early on the shoot day. They formed the center. As other aircraft came in, we marshalled them in sequence to build the four lines equally. Sheer luck brought in exactly eight Rutan VariEzes, making serifs for a perfect Roman numeral. I shot this from a helicopter, in heavy overcast.

Specs: Pentax 645 • 75mm
Fujichrome Provia 100 (film)
$^1/_{500}$ second, f/4, and ISO 100

Note: After all our efforts, editor George Larson overrode the photo staff and ran a faux nose art painting as the cover instead.

Gulfstream G650

Crafting an FBO ad, piece by piece

Clay Lacy Aviation requested a marketing image that would show its biggest Gulfstream G650 business jet, the ramp, hangar signage, and an upscale car poised to receive passengers. The client agreed that a wide, low ¾-perspective would work well to dramatize the elegant lines of Gulfstream's flagship.

The first consideration was camera placement: too high would hide the sign, and too low would cut off the winglet top. Lens choice was the next decision. Ordinarily I use perspective control lenses, to avoid converging lines. But here those lines would be advantageous, leading viewer eyes to the company name. The 24–105mm zoom lens I chose had the added advantage of fast, precise electronic focusing in low light. And re-framing the scenes would not require shuffling the tripod. We had only twen-ty minutes when all light sources would balance; any changes had to be done very quickly.

After settling on this angle, we locked the tripod down tight. As the sky darkened I made multiple exposures, planning to mask selections from each, then composite them in postproduction. Primary lighting was five AlienBees B1600s on the jet; that became the Photoshop base layer. In separate frames I lit the engine inlet, cabin and cockpit windows, wheels, winglet and stabilizers. The client himself drove the car, smoothly backing it up at various speeds to give pleasing taillight streaks.

In postproduction I adjusted the signage exposure, removed fence clutter behind the jet, changed sky color, removed ramp stains, darkened the foreground, and removed lighting reflections from the G650.

Specs: Canon 5D Mark III • 24–105mm at 35mm
5 seconds, f/18, and ISO 200

Note: Next time: I'd take some frames with the cabin door closed; and also some with a dark hangar door, to prevent the car ghosting.

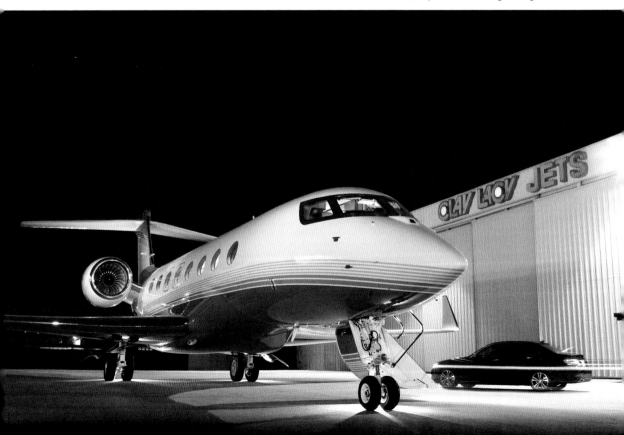

Cessna Citation V

*A timeless
silhouetted mechanic*

Specs: Canon 5D Mark III • 70–200mm at 190mm
$\frac{1}{200}$ second, f/6.3, and ISO 100

Note: A popular engine with an awkward name, the JT15D5
has sold almost 7,000 variants and accumulated over
46 million flight hours.

Aviation's MRO (Maintenance, Repair, and Overhaul) operations bear responsibility for maintaining an airplane's airworthiness. These folks are why it's safe to fly from New York to London in a business jet that's three decades old—or around the globe in an Air Force Boeing B-52H bomber built in 1961.

This shot was made for Desert Jet Maintenance, headquartered at Jacqueline Cochran Airport in California's Coachella Valley. The mandate was simple: create a web-friendly image that would stay relevant no matter how much MRO technology changed in the following five f.

The Pratt & Whitney Canada JT15D5 engine that powers Desert Jet's Citation V was the perfect subject. Thousands were built, and with a mean time between overhauls approaching 10,000 hours, they're going to be around for a long time.

And no matter the technological advances awaiting them, mechanics will continue to use flashlights.

But employees come and go, along with hair styles and clothing standards. So it made sense to position the jet's front fuselage just outside the hangar to catch the sun, but let the mechanic and the open engine nacelle go into shadow. A silvered reflector kicked in just enough light to bring out some engine components, but the flashlight looked awkward when lit so it stayed off. The final step was to expose for the sunlight, which perfectly silhouetted the mechanic.

Northrop Grumman X-47B at Rollout

Always bring a tripod

Specs: Canon 1Ds Mark III • 70-200mm at 185mm
$^1/_{10}$ second, f/8, and ISO 200

Note: The X-47B was the first unmanned jet to operate
from an aircraft carrier, and to execute an
autonomous midair refueling.

Beginning in seventh grade, I rode my bike to San Diego's downtown library every Saturday to devour that week's *Aviation Week & Space Technology* magazine. It was the aviation world's bible; decades later, it still is. Manufacturers and militaries alike court its reporters, vying for coverage.

So when word filtered out that Northrop Grumman was inviting select aviation press to the unveiling of the U.S. Navy's X-47B UCAS (Unmanned Combat Air System), I asked the magazine for permission to request credentials as its representative photographer. Sensing the photos would have resale value, I also offered to do it speculatively—AvWeek would pay only if the editors used any.

I arrived very early that day and got lucky: no other freelance photographer had been credentialed. Wandering backstage I saw a scissor lift and hitched a ride to the ceiling for wide-angle shots. Back on ground, I planted a tripod on the floor to make abstract nose-on studies as the lighting crew practiced its sequences. The shots later sold to *Aviation Week & Space Technology*, *Air & Space/Smithsonian*, and Northrop Grumman itself.

Once ceremonies began, there were no more opportunities to make head-on shots of the aircraft. The video team, however, had perched on a makeshift stage, where it had a head-on view of the audience and the X-47B; I spied this image on their monitor and wanted a still. They gave permission to hunker down beneath their camera. I quickly set up the tripod and got this hurried image just before the house lights went on. In post, I added blue to the foreground and removed yellow from the flag stripes.

Northrop Grumman RQ-4B Global Hawk Block 40

Rollout ceremonies: arrive early, blend in, and be ready

Aircraft unveilings borrow heavily from rock concerts. Expect ear-shattering music, quick-cut video clips, and dazzling lights. Alert photographers can piggyback off the sophisticated lighting to make striking images. The spotlights swivel quickly, and change hues even faster, creating multiple color shadings that add fleeting drama to a military jet's drab gray paint. The trick is to react quickly.

And, if possible, arrive early. When Northrop Grumman invited press to the rollout of its latest variant of the huge Global Hawk unmanned surveillance jet, I checked in two hours before the event's official start, carrying a nondescript camera case and small tripod. For thirty minutes, I wandered around, chatted and just watched. Wearing a coat and tie, with no cameras in sight, it was easy to blend in. The Global Hawk sat behind a gauzy curtain that doubled as a projection screen. Nobody yelled when I slipped behind it, so I set up the tripod and began making long exposures while the lighting technicians adjusted colors and brightness on the other side.

The scene changed suddenly when the video clip started. It splashed a broad beam of white light into the hangar, whose walls were painted blue by the gelled spotlights. Luckily, the video image turned out to be a gauzy image of a parked Global Hawk. It perfectly lit the "U.S. Air Force" lettering along the fuselage, and produced an island of white light that makes the photograph believable. I debated adding fill light to the tail, but the photo is arguably stronger without it. Our eyes always go to the brightest area of a photo; the dark areas here lead viewers to the USAF markings—and the Air Force is indeed the customer. I finished this shot and slipped back through the curtain.

Specs: Canon 1Ds Mark III • 24mm TS-E
8 seconds, f/8, and ISO 100

Note: The Canon 24mm TS-E tilt/shift lens was leveled on a tripod, then shifted vertically to include the V-tail tops without distorting the hangar walls.

Northrop Grumman MQ-4 Global Hawk
NASA Control Center

The power of large raw-format files in postproduction

These before-and-after images again show the advantages of shooting large images in camera raw format. That in-camera combination gives photographers wide latitude to change colors without banding, and to enlarge details without pixelation.

When the Armstrong Flight Research Center acquired a Global Hawk UAV, NASA marked its arrival with a press day. Pilot Mark Pestana patiently answered questions and posed for photos in the small, dark control room. I used the time to plant a tripod, add a cable release to my camera, and frame the shot. After the other photographers left, I asked Mark to give me three minutes.

The only room light was a ceiling spot aimed at the wall decor. The exposure of .3 seconds was long enough to capture monitor data but short enough prevent Mark blurring with movement. My camera's white balance is usually set to Automatic. That perfectly captured the room light's yellow ambience—accurate, but boring. In postproduction I lowered it to 2400 degrees Kelvin to force the room to go blue, then adjusted each of the small screens to read correctly. The large monitor's image was blurred, so I enlarged the most detailed screen—the UAV's schematic—and substituted it. The ceiling was retouched, Mark's uniform brightened, and magenta was added to the screen behind his head.

Specs: Canon 1Ds Mark III
- 17–40mm at 30mm
 .3 second, f/8, and ISO 200

Note: The screens at bottom left and right have realistic color, lending authenticity to the exaggerated colors in the rest of the photograph.

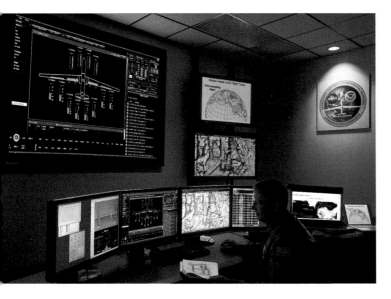

Cessna Citation CJ3 Simulator

Have a plan, but be flexible

Flight simulators are ground-based training systems that realistically replicate an aircraft's flight characteristics. Mounted on telescoping struts, some can buck like a bronco. Edwin Link built the first successful model, in 1929. I photographed these Level D CJ3 simulators at ProFlight in Carlsbad, CA as a self-assignment. The initial plan was to make a multiple-exposure image as they leaned and twisted, but the range of motion was actually very undramatic—they simulate a small business jet after all, not an F-16 pulling 9 Gs in combat. So I turned it into a static architectural study, lit with six Dynalite M1000X studio strobes. Barndoors controlled the spill light, and two narrow-beam grid spots name-checked the ProFlight logo.

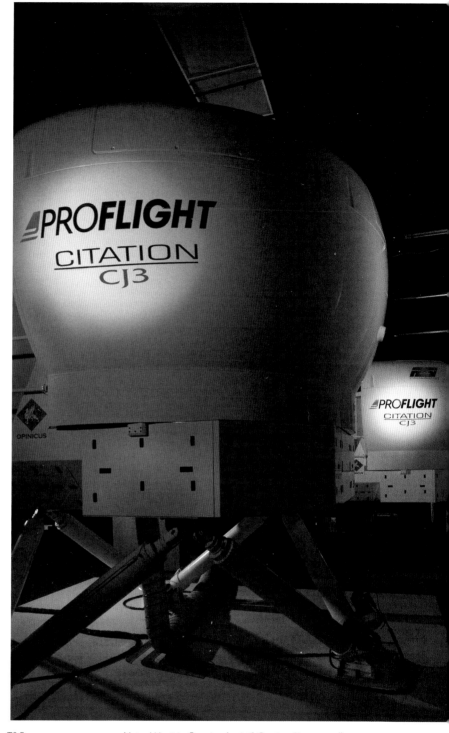

Specs: Canon 5D Mark III • 24mm TS-E
¹⁄₆₀ second, f/22, and ISO 200

Note: Want to fly a jumbo jet? Qantas Airways sells civilians time in its Sydney-based Boeing 747 simulator for $AUS1499 an hour.

Masten Space Systems Xaero-A

Balancing dusk light with strobe lighting

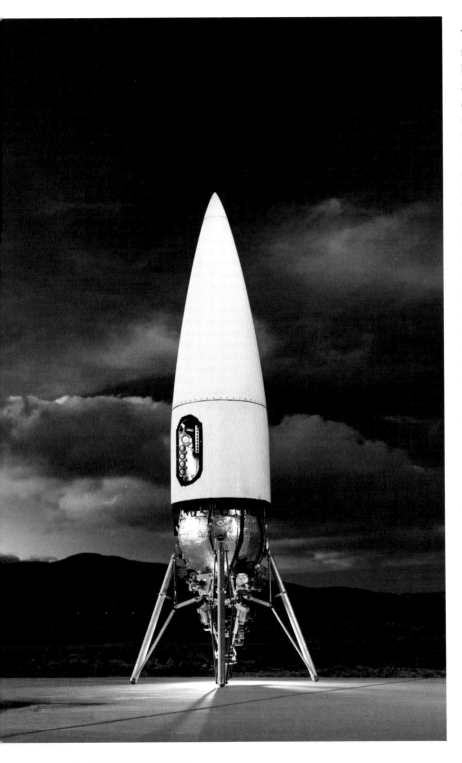

The Xaero-A was a reusable research rocket, built by Masten Space Systems to test various engine and material technologies. With its bottom fairings attached, it looked like a boring white bullet, so we removed them. The photo was made at Masten's Mojave Desert launch pad, lit by dusky sky light and three small strobe lights. A Norman 400B at camera right is the main source. One Nikon SB-26 at ⅛ power sits recessed into the open center panel. A second SB-26, mounted on the engine bell with a full CTO (*i.e.*, orange) gel, points straight down to mimic the rocket's exhaust.

Specs: Cannon 1Ds Mark III 24-105mm at 47mm f/5.6, .8 second, and ISO 100

Note: Just fourteen feet long, Xaero-A made 114 flights before being destructed on the 115th. Whimsy runs in the family; other Masten rockets are named Xoie, Xodiac, and Xombie.

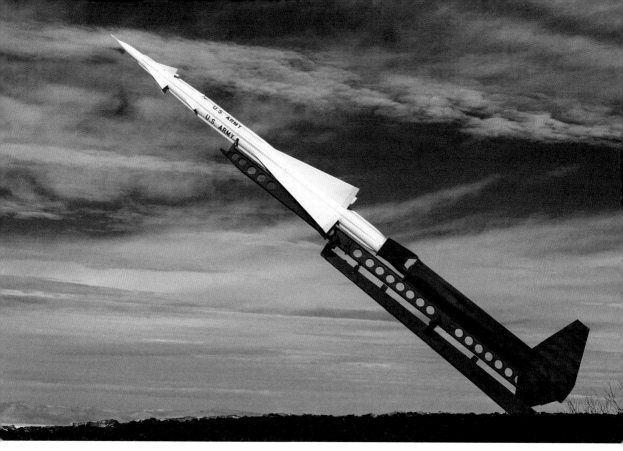

Douglas SAM-A-7 Nike Ajax

Software for black & white conversions

Specs: Canon 5D Mark III • 24–105mm at 85mm
$\frac{1}{1000}$ second, f/8, and ISO 100

Note: 13,714 Nike Ajax missiles were made. As they were retired, the boosters were repurposed to launch sounding rockets.

With time to kill before a job in El Paso, TX, I made a detour to the eclectic New Mexico Museum of Space History in Alamagordo, NM. Its rocket garden has a variety of rare missiles, including this well-preserved Nike Ajax surface-to-air guided missile. The two-stage supersonic interceptor was designed during the Cold War to shoot down attacking Soviet bombers. 265 Nike Ajax batteries ringed American cities and military bases between 1954 and 1963, and over 25,000 Nikes were built.

By crouching low with careful framing, it was possible to hide the museum sidewalks and urban landscape beyond. The actual missiles were launched vertically, soaring high above incoming aircraft, then diving down at speeds impossible to evade. This angle, fortunately, is much more photogenic.

The original is in color; it's nice. But the 1950s were a black-&-white era. Friends and press reviews alike had recommended MacPhun's Tonality photo software for converting color photographs into images that look like they just emerged from the fixer bath in a traditional film darkroom. This frame seemed like a perfect candidate, and it was. I noodled through the dozens of automated presets, chose one, adjusted some sliders, and in ten minutes was finished. I felt only slightly guilty.

Boeing BBJ Flight Deck

Flight deck exposure techniques

I begin by covering the window exteriors with white diffusion material. Medium-weight polyester cloth works well, cut from long rolls bought at fabric stores. Over the years, each time I've photographed a new aircraft type, I've measured their cockpit windows and cut cloth to fit them. Cutting these templates with pinking shears, then coating the edges with Fray Check liquid sealant, builds a library over time of tough diffusion panels that can be washed and used again multiple times.

Next, I hide all the visual clutter, including pens, charts, manuals, and headsets; then, close the air vents; align the chairs as much as possible; align or hide the sun shades; lower the HUD display; and hide the seat belts.

The line crew then positions the jet on the ramp with the nose away from the sun, to minimize lens flare caused by the bright window light. A pilot or mechanic brings up the screens, with as colorful displays as possible. I plant a tripod dead center, frame an ultra-wide view, set the aperture to f/16, and make five bracketed exposures from ¼ second to 4 seconds in one-stop increments with an ISO of 100. I'll then zoom in tighter for an alternative view, but always include both yokes.

If the instruments overexpose from reflecting the cockpit windows, I make additional exposures, inserting a Matthews Roadrags 18x24-inch scrim frame/black flag combination between each screen and the windows. I later select and drop in the now-flawless screen during postproduction. With layers, I can also balance cockpit highlight and shadow detail by choosing between the five exposures.

Specs: Canon 5D Mark III • 17-40mm at 40mm
 f/16, 2 seconds, and ISO 100

Note: To avoid failure readouts on displays and to
 enable airshow moving maps, the navigation
 system must be aligned.

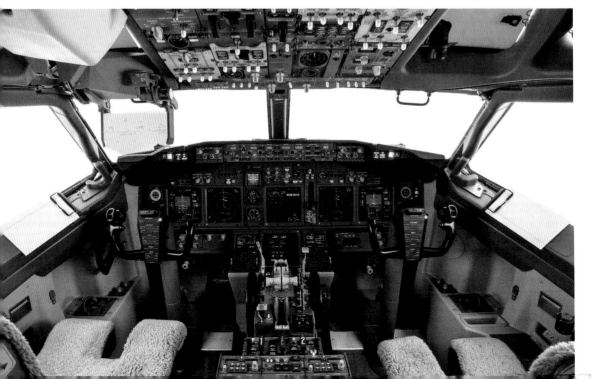

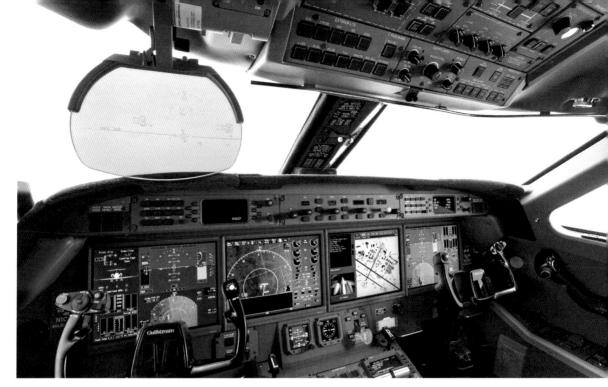

Gulfstream G550

Photographing
the flight deck HUD

Specs: Canon 1Ds Mark III • 17-40mm at 17mm
f/16, 4 seconds, and ISO 100

Note: HDR (High Dynamic Range) options exist that
automatically maximize tonal range, but the results
rarely look authentic.

Most flight deck photographs are made from a symmetrical, straight-down-the-aisle position. Here, however, is what a G550's pilot actually sees. I was in the left seat, with the tripod straddling the armrest and center console. There is only one angle where the HUD (head-up display) was visible, and that dictated the exact camera position. With the lens aperture at f/16 (for maximum depth of field), I squeezed off exposures of ¼, ½, 1, 2, and 4 seconds with a cable release. There was no supplementary lighting. In postproduction, I stacked various layers and then feathered in selections to balance shadow and highlight details.

HUD displays are challenging to render. The light green display is only visible from one narrow angle, and it's very low contrast. It's best photographed through another series of five bracketed photographs, but centered on an exposure one stop darker than your previous fastest shutter speed. For example, the base image was composited from five exposures at f/16, from ¼ through 4 seconds. Without moving the camera, I then made another five exposures from ¹/₁₅ to ¹/₂₅₀ second to capture only the HUD screen.

Adjusting the HUD's proper color and exposure can be done in postproduction with Adobe Camera Raw. For this image I picked the best HUD exposure and began with +100 overall contrast. Green saturation and luminance were both bumped up to +100. Finally, the purple and magenta controls were manipulated to contrast with the green. After selecting the HUD, I improvised with *Layer Style>Blending>Darken>Blend If: Green* and somehow got a pleasing result.

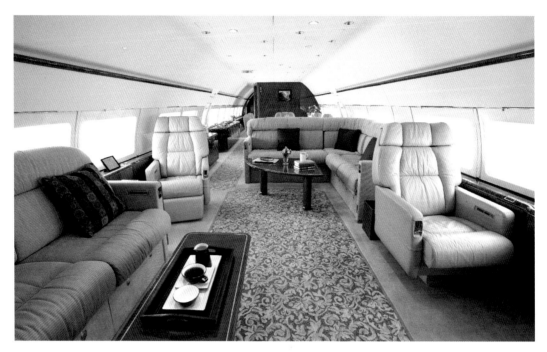

Boeing BBJ
Business Jet Cabin

The basics

Specs: Canon 5D Mark III • 17–40mm at 40mm
f/16, 2 seconds, and ISO 100

Note: Empty coffee cups look incomplete to me.
Cola looks just like coffee, so I always bring a
16-ounce bottle of cola on each shoot.

The primary markets for business jet photography are brokers who sell used jets, and air charter companies who fly passengers on private flights. Both clients require clean, well-lit shots that show the aircraft to best advantage. The key word is private; photographers are expected to protect the privacy of the jet owners. No celebrity or CEO wants photos of their aircraft's gold-plated seat buckles showing up on the internet.

My approach to interiors is simple: cover the windows on the outside with diffusion paper, set the camera at f/16 on a tripod aimed down the aisle, make five bracketed exposures one stop apart, and adjust color and exposure later in Photoshop. The shots are made outside the hangar, with the tail facing the sun to minimize cockpit window flare. The diffused window

sunlight produces an open, bright cabin. Upwash lights add welcome fill, but illuminated downwash and reading lights usually create hot spots on seats and weird shadows on the aisle carpeting.

Business jet cabins typically have several well-defined seating arrangements, called zones. Each one gets photographed from seatback level, eye level, and ceiling level. I start at the flight deck for views from front to back at each zone, then reverse direction and shoot each zone looking towards the front. Some clients also like oblique shots, especially of the conference/dining table. I wrap up with interior views of the galley (kitchen), forward and rear lavs (bathrooms), crew rest compartment, and on large jets like this BBJ, the bedroom and shower.

Bombardier Challenger 605

Styling business aircraft cabins

Aircraft interiors, like houses for sale, are "staged" for photo shoots. For most of my 500+ jobs, I've done it myself. Over the years, I've moved to a far simpler, but more sophisticated, approach to styling the cabin: uncluttered table settings, no food, and fewer floral displays than in years past. That, and using small glasses, plates, and vases, also makes the tables look larger.

It's smart to keep notes on each client's preferences. Brokers often want their brochures visible somewhere, to prevent other brokers from poaching their photos. Companies marketing to Middle East clients don't want alcohol or even wine glasses visible. Some charter operators like to see cockpit doors open; others want them closed to assure clients of complete privacy during flight. Personally, I think seeing into the cockpit makes the plane look longer and more exciting.

Many jets have monitors built into bulkheads, for showing DVDs or moving-map displays. They're strong selling points. It's important to make closeup shots of the display screens, to later enhance and insert during postproduction. I've built up a library of screen shots and DVD movie stills to swap in. That's helpful if the monitors are temporarily malfunctioning—and yes, I charge for the extra postproduction time.

In this shot, I included the broker's brochure on the divan; hid all seat belts to keep seats uncluttered; added saturated color to the moving map display (and chosen a North America map to emphasize this jet's transcontinental range); and bumped up the Clarity slide in Camera Raw to bring out the patterns in the chair coverings and carpet.

Specs: Canon 1Ds Mark III • 17–40mm at 40mm f/16, 8 seconds, and ISO 100

Note: Two more details: (1) center all reading lights and air vents (2) open every window shade fully, using hidden tape if they won't stay up.

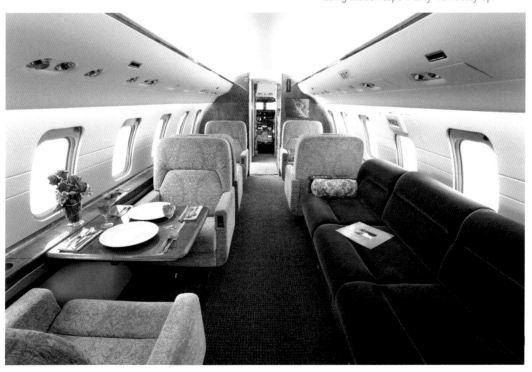

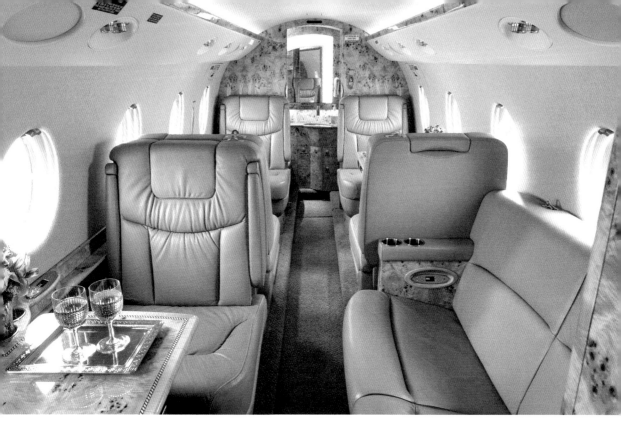

Gulfstream G150

Refining cabin interiors in postproduction

The puckered seats and leopard-skin wood veneer may not be to everyone's taste, but our job is to show every interior at its best. A lot of that is done in postproduction, with Adobe Photoshop.

I shoot everything in raw format, for maximum flexibility and zero risk. On the job sheet, I note the colors of a jet's ceiling, seating, and sidewalls. Opening the base exposure file in Adobe Camera Raw (ACR), I adjust the color temperature, usually reducing yellow and green casts caused by the upwash ceiling lights in older aircraft. Subtle adjustments with ACR Hue/Saturation/Luminance sliders can further refine color accuracy.

The next step is to balance overall exposure detail. Pushing the sliders to +50 Shadow and −50 Highlight detail is a good starting point. To deal with exposure extremes, bring in what you need from the four bracketed exposures.

If forensic accuracy had been critical, I would have removed the yellow from the lavatory backsplash. But it adds a touch of warmth, and some color contrast, so it stayed. The window areas, however, turned blue when the color temperature was adjusted to compensate for the yellow ceiling lights. So the next step was to select them (and the silver tray, which reflected the blue) and desaturate them back to neutral. Last, I used a Hue/Saturation adjustment layer to remove most of the yellow cast from the upwash lights.

Specs: Canon 1Ds Mark III • 17–40mm at 24mm f/16, 3.2 seconds, and ISO 100

Note: Diluting one part cola to ten parts water substitutes for white wine. Red wine, real or fake, doesn't photograph as well so I don't use it.

Grumman HU-16RD Albatross

When the airplane is also a boat

Seaplanes are already a curious engineering hybrid of boat and aircraft, but this owner's decision to turn his HU-16 into a flying yacht ratcheted up eclecticism to new levels.

The Albatross entered military service in 1949 as a long range, open-ocean search and rescue aircraft. When surplus examples began turning up, the twin-engine amphibian's reputation as forgiving to fly made it attractive to civilians looking for an unusual warbird alternative. It also had, as one pilot put it, "good water manners."

Specs: Canon 1Ds Mark III • 17-40mm at 17mm f/16, 2 seconds, and ISO 100

Note: In 1997, this HU-16 retraced Amelia Earhart's last flight, continuing on to become the first HU-16 to circumnavigate the globe.

A corner shot made the most sense for this interior. The overhead lines lead the eye directly to the flight deck, whose rounded step-over threshold clearly shows this is a boat. The angle also highlights the oversized windows, which promise vistas more typical from yachts than from executive aircraft.

A note on camera placement. Typically, I'll shoot each interior zone from three camera heights: slightly below eye level, slightly above the seatbacks, and inches below the ceiling. This gives the client choices. If the camera has a built-in level indicator, use it to align the verticals. Then switch to live view and zoom in on window frames for accurate vertical alignment. Including a hint of seat backs helps to frame the photo without making them a dominant (and unnecessary) feature. Finally, using a 17mm or 24mm perspective control lens gives accurate verticals, broad coverage, and freedom to control how much or how little ceiling is included.

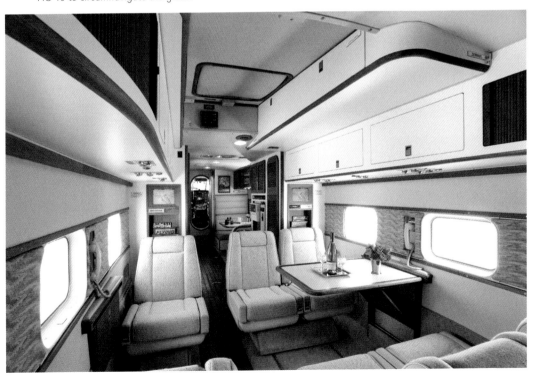

Cessna Model 510 Citation Mustang

Photographing the smallest aircraft interiors

Interiors don't get much smaller than in the Mustang. Its four-seat cabin is barely nine feet long and less than five feet wide and tall. Here area ideas for making tiny jets look a bit larger:

— Use a focal length wide enough to show most of the cabin, but not so wide that the edges look distorted. Resist the urge to use a semi-fisheye lens: clients don't like them.

— Squeeze the camera into a corner and aim it towards the opposite corner. If you can't use the viewfinder or Live View, compose the shot remotely with a wireless tethering system.

— If the space is too tight for a tripod, strap the camera onto a bean bag like the Green Pod. Set the camera's focus and aperture, then enable a five-stop bracket. Attach an electronic cable release or use an app for vibration-free shutter releases; PocketWizard remotes are another alternative. Steady the camera/Green Pod combination in a level position atop a seat back. Fire away.

— Tilt the adjoining seatback rearwards just enough to minimize wide angle distortion.

— Use small props, and not many of them.

— If the shoot calls for people in the seats, use compact models. A petite 5'2" businesswoman will fit far more comfortably than a 6'2" guy overflowing the seat while crunching his tilted head against the curved headliner. And she'll make the jet look much roomier.

— Keep it light; bright spaces look bigger than dark spaces. Open up the shadows in postproduction.

— Unless the engine is running to give you cooling, small cabins can get very hot, very quickly, when parked on the ramp during a hot summer day's shoot. Stay seriously hydrated.

Specs: Canon 1Ds Mark III • 17-40mm at 28mm f/16, 2 seconds, and ISO 100

Note: Think twice before putting props on the seats; it can look like the photographer set something down, then forgot to pick it up.

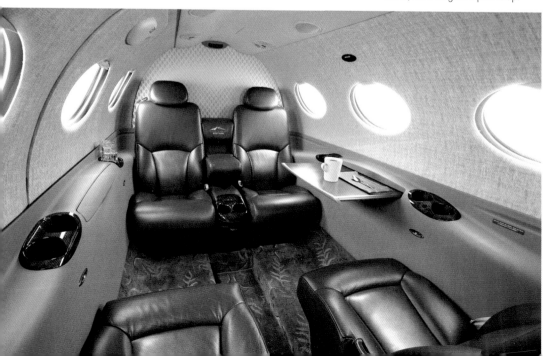

Bombardier BD-700 Global Express

Photographing the flight deck displays

The difference between a cockpit and a flight deck, most agree, is that pilots climb in and out of a cockpit (think fighter jet), but walk in and out of a flight deck (think airliner).

Semantics aside, flight decks present some of the biggest challenges in aviation photography. Those large windows spill flare all over the dark glare shields. There is a huge tonal range between the bright sheepskin seat covers and the dark rudder pedals. And it is nearly impossible, given the time constraints involved when doing a complete front-to-back aircraft shoot, to light a cockpit without reflections bouncing off the multiple glass-fronted displays.

As noted previously, one solution is to cover those windows with thin white cloth, then photograph on the ramp in daylight. The instrument displays, however, require individual attention. Besides the magenta HUD, there were fourteen displays in this shot. Each one had to be flagged off during the original shoot to eliminate side window reflections. In post-production, I chose the best exposure for each from the five bracketed frames. After selecting each display, I warmed and saturated the colors, increased contrast, and adjusted clarity. Last, I copied and pasted it into my working TIFF file.

Sometimes an instrument will be non-functioning. If the client requests, it's relatively easy to select a comparable display from a previous shoot of the same airplane type, then use Photoshop's Edit>Transform>Distort function to swap it in.

Specs: Canon 5D Mark III • 16-35mm at 16mm
1 second, f/16, and ISO 100

Note: The term "flight deck" probably traces to early flying boats; pilots sat on a small enclosed, raised deck separate from passengers.

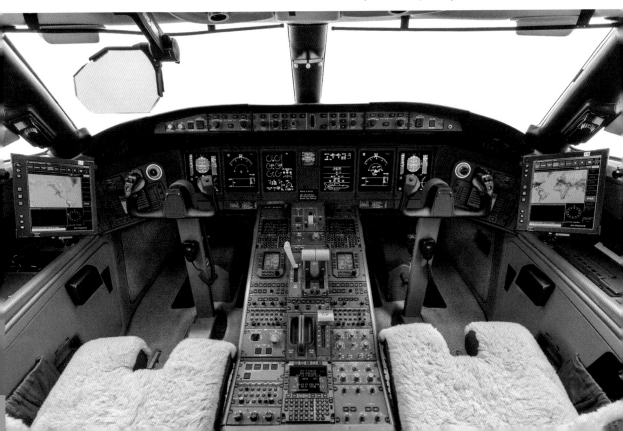

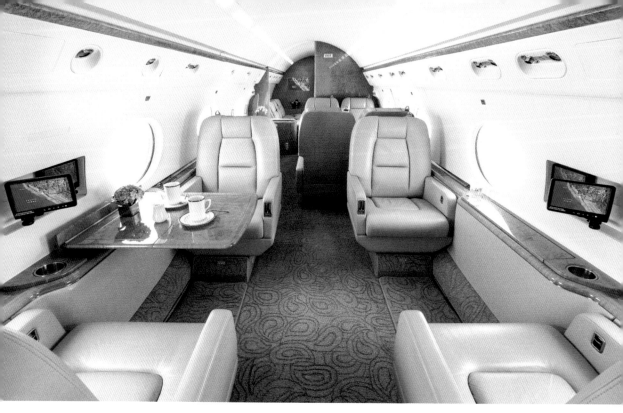

Gulfstream G-V

Cabin entertainment systems

Specs: Canon 5DS • 16-35mm at 16mm
f/16, 3.2 seconds, and ISO 100

Note: The first seat on a large jet's starboard (right)
side is often called the VIP chair; it usually has
controls for cabin lighting and audio.

Nearly every business jet has an entertainment system for passengers, with offerings that range from maps to DVD movies to iPhone connectivity to live television eight miles high. A California company named Airshow introduced the first moving map system in 1982; the name, although still trademarked, has become a generic term for monitors that show a jet's location, airspeed, and altitude.

Great for passengers; problematic for photographers. One imagines a 7-inch monitor costing $25,000 would work flawlessly, but the only cabin features that malfunction more often are the upwash and downwash lights. The displays are too often broken, washed out, or unable to connect to the navigation system. When they do work, display colors may be wildly mismatched.

So, similar to the workflow for adjusting cockpit displays, each cabin monitor needs to be individually adjusted. If the displays are operational and the color is good, that simply involves making a selection and then tweaking them with the Hue/Saturation/Luminance and Clarity controls.

If the small displays are bad, sometimes the large ones on the bulkhead are functioning. In that case, turn off all lights, close the windows, and shoot some closeups of various map displays. Those images can be resized in postproduction, then inserted into the smaller displays. Over time, you'll build up a library of various maps. If you run across a jet with every monitor broken, you'll be able to borrow the appropriate screen and copy it in.

Dassault Falcon 2000EX

Covering the windows

Structurally, a business jet's cabin is simply a long dark tube, with a few small holes punched into the sides for windows. Covering those windows with exterior diffusion softens and spreads incoming sunlight. That opens up shadow detail in carpeting and the ceiling, while muting overexposed highlights on the window frames, table props, and seating. As a bonus, diffusion hides the view outside; it's easy to imagine the aircraft is streaking through bright clouds toward blue skies above.

I prepare the diffusion the day before a shoot. Over the years I've compiled a list of window sizes. The Falcon 2000EX has 18 windows, each 11x15-inch. That is an easy solution: Canson makes 50-sheet pads with neutral white 14x17-inch tracing paper that perfectly covers not only Falcon windows, but also Challenger 604, Gulfstream G200, and most Citation windows. Clearprint makes pads of 11x17-inch vellum sheets that exactly fit Hawker jets.

Gulfstream's oval, oversized 19x26-inches windows are not as easy. I cut 24x28-inch strips from 2x50-foot rolls of Seth Cole #58 (16-pound) parchment paper, staple them together, then trim them down to a more manageable 21x28-inch size that neatly covers most Gulfstream windows.

If time allows, I carefully remove the papers after a shoot to use again. If not, they are inexpensive enough to throw out.

To protect the aircraft's paint, I attach the paper with Scotch Blue #2090 painter's tape. If Scotch Blue won't adhere to ultra-waxed fuselages, use Scotch Green #2060. Never use cloth gaffer tape.

Specs: Canon 5D Mark III • 16-35mm at 16mm
2 seconds, f/16, and ISO 100

Note: Rosco Cinegel #3026 Tough White Diffusion is extremely color neutral, but heavy and expensive. I prefer Clearprint or Canson tracing paper.

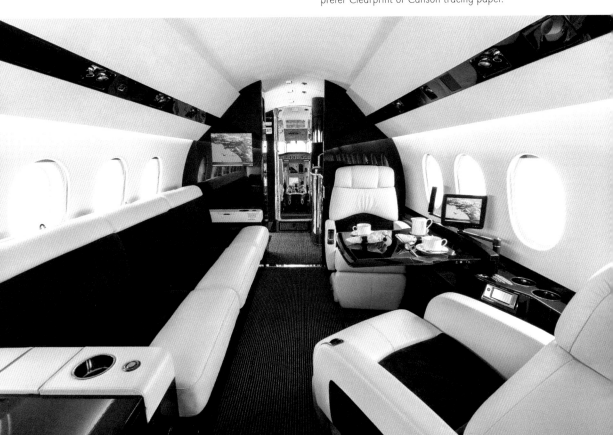

Gulfstream G-V Lavatory

Composition and exposure techniques for the lav

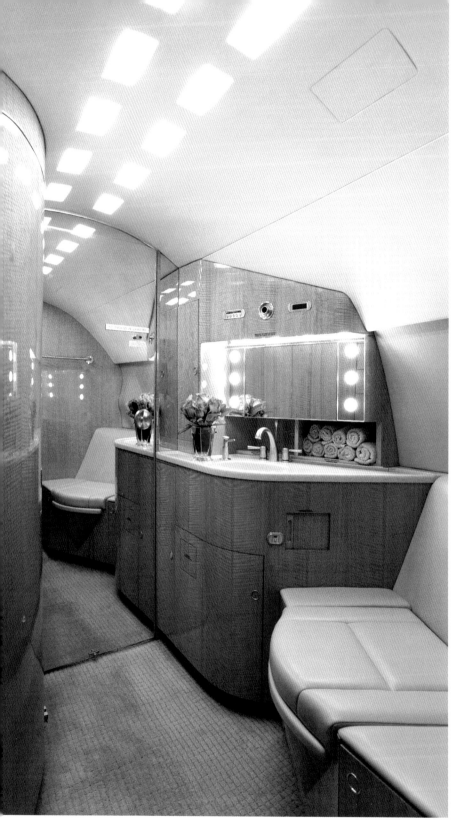

The combination of multiple mirrors, tiny spaces, disparate color temperatures, and top lighting makes bathrooms (called "lavs," short for lavatories) a bit challenging. I usually squeeze into a corner, then open the door (inevitably mirrored) just enough to hide me but reflect the toilet. Always bring some upscale, neutral color washcloths and hand towels as props, since many lavs are stocked with paper towels—good hygiene, but downscale for visuals. Including a small bouquet adds a touch of much-needed color, and can also hide an ugly electrical outlet or placard. Finally, use a Westcott Ice Light to brighten the low cabinets; you'll get reflections, but can remove them in postproduction.

Specs: Canon 1Ds Mark III • 17–40mm at 35mm
f/8, 1 second, and ISO 100

Note: About 95 percent of my photos are horizontals, since about 95 percent of their use is on web pages. But for this jet, I added some verticals to include the unusual ceiling lighting. One other thing: I rarely open up the little door that hides the toilet paper. Everyone knows it's there.

Boeing BBJ Business Jet Lavatory

Render color accurately

Most jet lavatories incorporate multiple light sources, each emitting a different color. Windows go bluish, reading lights burn orange, and upwash fluorescents glow green. Start by jotting down fixture colors; if it's difficult to see them, they usually match the main cabin's upholstery, countertop, headliner, and cabinetry colors. Check that the camera is capturing raw files, then choose the "Average White Balance" setting. Set the aperture and make a series of five exposures one shutter speed apart. In post-production, Photoshop's Temperature and HSL sliders allow raw files to be easily adjusted and combined, bringing each light source back to a realistic color.

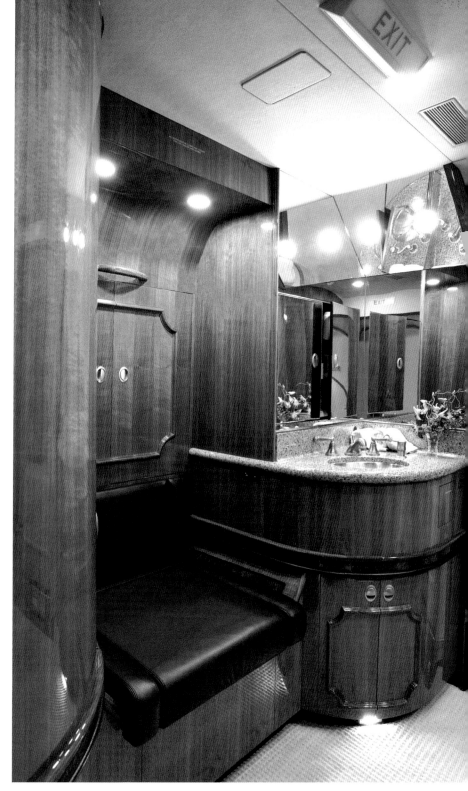

Specs: Canon 1Ds Mark III • 17–40mm at 22mm
f/8, 15 seconds, ISO 100

Note: Lavs with multiple light sources produce multiple specular reflections. I retouched out the ones that distracted from the wood's beauty, but left in a few to show that the wood has a high-gloss finish that's easy to clean. And because the lights were clustered at the top, I "painted" the lower half with an Ice Light to fill in the shadows.

Cessna Citation CJ3

A checklist

Checklists help photographers the same way they help pilots. Here are excerpts from the one I use inside the hangar as I prepare the jet's cabin. (Always request the jet be hangared the night before, to keep condensation off the exterior and to give you a protected place to apply window diffusion.)

— Bring aboard drinking water, wet wipes, gaffer and painter tapes, a 4x8-foot black scrim to control reflections, a Westcott Ice Light, and a bottle of cola to pour into coffee cups.

— Open all window shades completely. If they won't stay open, insert some rolled-up painter's tape.

— Align the reading lights and air vents. Leave reading lights off; they cast ugly shadows on carpets.

— Turn on all upwash lights. If even one is burned out, turn them all off.

— Remove throws, pillows, snack baskets, plastic water bottles, magazines, and tissue boxes.

—Hide all seat belts if shooting for charter; if for a broker, leave two visible to show the buckle finish.

— If the carpet is nice, remove protective floor runners and floor mats.

— Align seats with each other, and raise all backs to vertical. Resist the urge to show them swiveled.

— Align divan cushions with each other.

— If the galley stemware cabinet has clear doors, fill at least the front row with glasses.

— Open galley doors and decide which, if any, have nice appliances worth showing.

— Check that the galley sink, lav sink, and lav mirrors are all spotless. If not, wipe them down.

— Use onboard china and stemware, no matter what you personally think of their style or designs.

Specs: Canon 5D Mark III • 17–40mm at 40mm
f/22, 1 second, and ISO 100

Note: When photos are used to sell charters, I usually retouch out cabin warning signs; when used by brokers to sell the aircraft, I leave them.

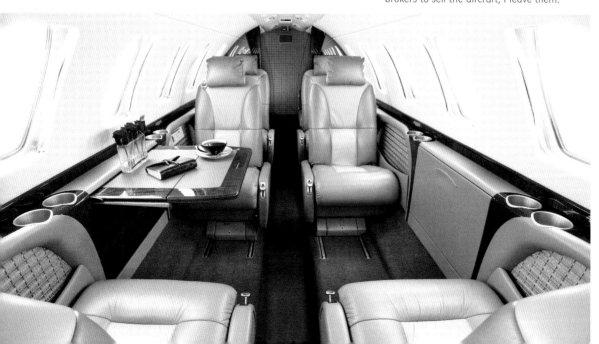

Gulfstream G550

Balancing exposure extremes

Large business jets are perfect for extended flights. This G550 can fly nonstop between Los Angeles and Shanghai in thirteen hours. Like other aircraft in its class, it features divans and seats that convert into beds. A passenger can depart Los Angeles at 7PM, eat dinner, relax, sleep for eight hours, and arrive in Shanghai refreshed for a business lunch the next day.

Charter companies promote this capability in presentations to corporate executives. The challenge for this shot was keeping the cabin dark, but subtly spotlighting selling points. The solution was to use the small tungsten reading lights. They were on swivels; turning them made it possible to focus their beams on individual items. The monitor, and the book on the bed, suggest ways to relax. Slippers on the floor and blankets on the bed promise a comfortable sleep environment at 41,000 feet. The flowers

add a splash of natural color to soften the jet's hard industrial components. One light showcases the rich credenza wood.

But the difference in brightness levels between the brightest part of the bedspread, and the hint of wood visible on the bulkhead, was 12 stops. I made seven bracketed exposures at f/16, from ½ through 30 seconds. Using the 4-second frame as a baseline, in postproduction I feathered in selections from other exposures, sometimes adjusting contrast and exposure even further. The white sheet reflected light onto the walls and ceiling. I spent some time removing the yellow color made by the tungsten lights, but kept the walls and ceiling a bit warm to enhance the mood.

Specs: Canon 1Ds Mark III • 17–40mm at 20mm
f/16, 4 seconds, ISO 100

Note: A cautionary note: many clients prefer to show the berthed compartment with window shades open—always ask their preference.

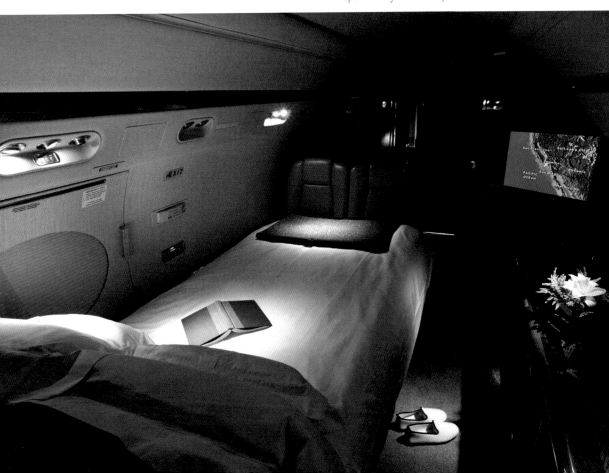

Embraer Legacy 600

Cabin details

Specs: Canon 1Ds Mark III • 45mm TS-E
f/8, .5 second, and ISO 100

Note: If a client requests upscale food on dining table
plates, caterers who specialize in business jet
meals will often trade them for photos.

Brokers and charter clients alike occasionally request closeup photographs of attractive details. On the aircraft's exterior, popular subjects include winglets, "N" numbers, engines, inlets with turbine blades, and distinctive livery designs. A client once asked for a shot of the jet's data plate.

Inside the cabin, the list is almost endless: individual seats both upright and reclined, elegant seat stitching, galley appliances, cabin control panels, divans, table marquetry, VIP seat controls, custom carpet patterns, seat-side monitors; bulkhead monitor displays, flight deck instruments, dining setups, and lav countertops are all candidates if they merit close attention.

This shot was made early in my career, when industry marketing focused on the luxurious side of private jet travel. There was no such thing as excess. Cabin tables were photographed groaning under the weight of expensive wines, elegant plates crowded with beautiful slices of filet mignon, and gorgeous desserts. Elaborate floral displays towered over credenzas.

That styling trend screeched to a halt in November 2008, when news broke that the CEOs of Ford, Chrysler, and GM had each flown their individual company jets to plead for financial bailouts from Congress. Word soon came down to photographers: dial back the luxury; give us a simple business look.

Just for something different, I used a 45mm tilt/shift lens to photograph this colorful dessert platter from Stevie's Catering, putting selective focus on the tops of the pastries.

Gulfstream G-IVSP

Showcasing the galley

Most midsize and larger business jets incorporate a dedicated food preparation area. Never refer to it as a kitchen—it's the galley. The term, like many in aviation (captain, steward, rudder, lav, tug, cockpit and berth are some others), is a carryover from ship and rail travel traditions.

Like lavatories, galleys are usually dark, toplit, and small. The photography procedure is similar: use an ultrawide lens set to f/16 for good depth of field, attach the camera to a sturdy tripod, determine a base exposure that shows a good histogram, then bracket the shutter speeds around that to produce five exposures one stop apart from each other. Exposure levels and color correction can be adjusted through judicious use of postproduction techniques.

I'm usually compulsive about keeping the camera level, to avoid converging lines. But doing that here (and in most galleys) would have included too much ceiling, and cropped out too much floor and storage space. Clients won't complain if cabinets are converging, but they will if the cabinets are missing.

This was shot for a broker; if it were for charter, I would have positioned a juice, coffee, or wine service setup on the left counter. I would also have added a small floral display to kick in a splash of color. I left the lav door open to increase the feeling of spaciousness.

Specs: Canon 5D Mark III • 16-35mm at 16mm
2 seconds, f/16, and ISO 200

Note: The first commercial aircraft with a built-in galley
was the Fokker F-32, which began scheduled
service in 1930.

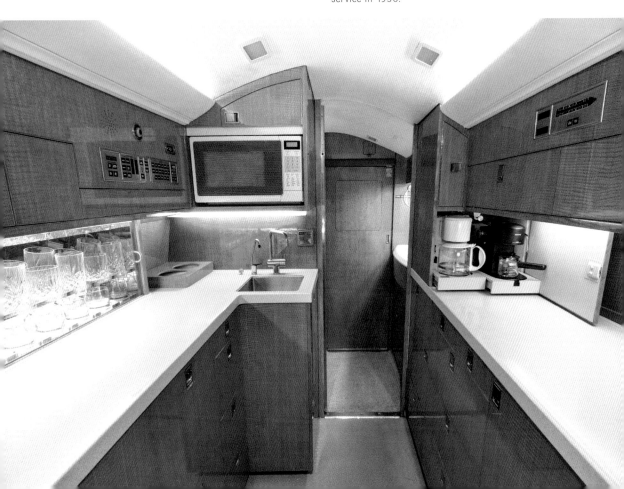

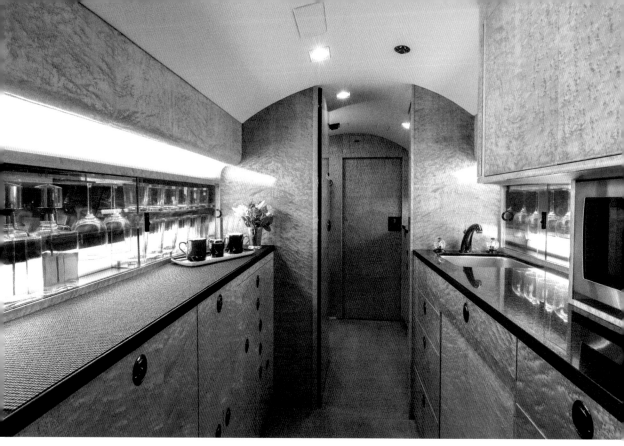

Gulfstream G550

Galley tips and tricks

Specs: Canon 5D Mark III • 16–35mm at 16mm
f/16, 4 seconds, and ISO 100

Note: Take note of the liquor decanters at far left.
Deferring to potential Middle East clients, I'm
often told to omit any alcohol references.

Like lavs, galleys often have mismatched lights, producing weird colors that must be corrected in postproduction. One simple way to do that is make duplicate layers, then use the Camera Raw HSL slider to desaturate light source colors one at a time. In this photo, I removed yellow from the ceiling (coming from the recessed tungsten lights) and green from the stemware cases (caused by the fluorescent panels above and behind the glasses).

Some clients want to show galley appliances and amenities; others want all cabinet doors closed. Inquire ahead about their preferences, or photograph the galley both ways.

Most galley sinks have covers. I remove them if the basin is nice, for visual relief from the long countertop. I angle faucets to show a bit of their profiles. A coffee service is showing here; a good substitute is a simple tray with two glasses of orange juice. The small floral arrangement adds a spot of color.

What's not visible in the photo are multiple reflections on the glossy wood panels and countertops. The surfaces look visually cleaner with those distractions retouched out.

Also removed, as usual, are the multiple warning placards. The lavatory was much darker, but I wanted it to show, to enlarge the visual space. Placing a full-power, tungsten-gelled Ice Light vertically on the toilet lit the lav perfectly.

Dassault Falcon 2000

Preproduction coordination with the client and the FBO

Preproduction is boring; get over it. In an age when airport access is tightly controlled, detailed planning and communications are essential. Start by determining the airport's photography guidelines. If you're shooting on a ramp, chances are you'll need a permit. That typically involves giving a minimum five days' notice to the airport, submitting an insurance certificate that names it as an additional insured, and paying a fee. (The fee is often waived if the aircraft operates from the field.)

If the jet has its own hangar, contact the pilots to negotiate a mutually agreeable shoot date. Give them a detailed timeline. Confirm that external power is available; if not, they (or a mechanic) will need to run the aircraft's APU (Auxilary Power Unit) or an engine for a few hours. If the jet is hangared with others at an FBO (fixed base operator), either you or a pilot needs to coordinate with the FBO manager for scheduling, access, rollout, tow services, and ramp positioning. Avoid Mondays and Fridays when possible; line crews are busiest those days and cannot quickly respond to anyone not paying the bills by buying fuel.

After all your planning, don't be surprised if the shoot suddenly gets cancelled. That can happen if the owner decides to fly, if a charter gets booked, or if a serious mechanical issue develops. It's so common that I don't charge a cancellation fee. Notify the airport operations office about the cancellation, then use the day to develop new business or sharpen your video skills.

Specs: Canon 5D Mark III • 16–35mm at 20mm
8 seconds, f/16, and ISO 100

Note: Always give control tower personnel advance notice if you'll use strobe lighting at night anywhere within their sight.

Boeing 757-200

The hero dusk shoot, Part 1: Planning

Executive aircraft look stunning when photographed at dusk with strobe lighting. Because most of them are painted white, they pop out against a dark airport background and deep twilight sky.

But nothing draws the attention of control towers and airport police like a series of unexpected powerful flashes. Conversely, photographers who plan out the shoot in advance with proper permits can expect, at minimum, a courteous tolerance. Begin by securing permission from the FBO (fixed base operator) whose ramp will be used. Ask the manager to (1) send notice of that permission to airport operations, and (2) notify the tower to inform controllers working the dusk shift that there will be intermittent lighting.

On the day of the shoot, negotiate with the line crew for a spot on their ramp that includes an attractive view of the airport, but excludes other airplanes. Line crews are the folks who will move your plane into position, and can move others out. They work longer and harder than anyone else in aviation, outdoors in weather that would kill lesser souls. Treat them nicely, tip them with $20 bills, and thank them profusely. They can make or break your shoot.

Mid-afternoon, tell them where you'd like to position the jet for the dusk shot. Request that it be towed there ninety minutes before sunset.

Specs: Canon 5DS • 70-200mm at 105mm
6 seconds, f/8, and ISO 200

Note: What look to be reflections in water are reflections from a just-polished white hangar floor, with the camera perched inches above.

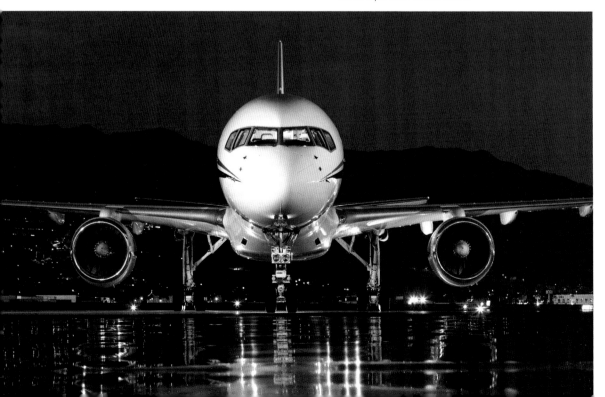

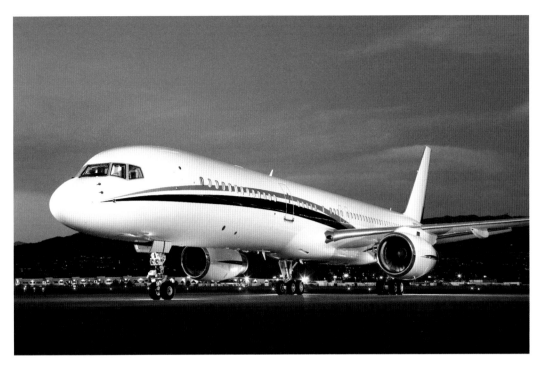

Boeing 757-200

The hero dusk shoot, Part 2: Execution

Specs: Canon 5DS • 45mm TS-E
f/8, 2 seconds, and ISO 200

Note: If the airport's background has point-source security or parking lamps, f/8 or smaller apertures can produce natural star effects.

With the jet in position, it's time to set up the lighting. Some photographers simply set the shutter on Bulb, and then walk around the jet while manually tripping a handheld strobe; an assistant covers the lens between flashes. Since I work without an assistant (no liability or workman's comp to worry about), I set up individual lights.

As sunset approaches, I begin to monitor airport ground and tower frequencies on an ICOM air band receiver. I never trip the strobes when a moving aircraft is approaching, or when a controller might be looking towards them at a taxiing or departing aircraft. I also wait 15 seconds between photos, to avoid rapid-firing strobes; at best that calls attention to the shoot, and at worst it can affect controllers' night

vision. As part of the planning process, I've arranged for a pilot or mechanic to arrive at sunset. When the sky is dark enough that cabin lighting will show through the windows, I ask for APU or engine power, brakes on, and all cabin lighting along with the wing tip position lights turned on.

For the next 30+ minutes I make multiple exposures at f/5.6 or f/8, progressively lowering the shutter speed as light levels decrease. When the windows no longer reflect skylight, I make a series of bracketed exposures for just the window and cockpit light; they become window glow "plates" that I can use in postproduction. The most important shot is a forensic nose-to-tail profile view, but three-quarter views like this possess drama that make them valuable promotional photos.

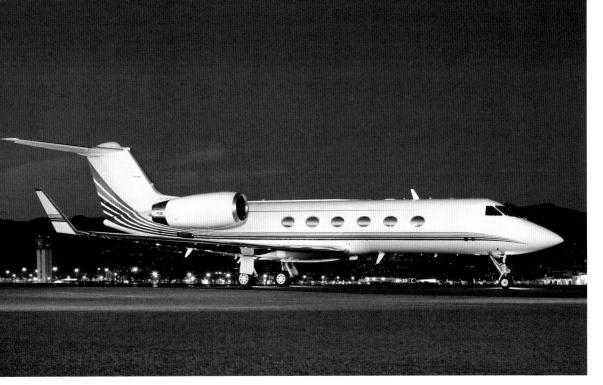

Specs: Canon 1Ds Mark III • 45mm TS-E
2 seconds, f/8, and ISO 200

Note: This was the rare evening when the cabin windows looked better with sunset reflections than with internal lights showing through.

Gulfstream G-IV

Dusk lighting with eight strobes

My lighting doesn't change too much from jet to jet. I line up three Paul Buff AlienBees B1600 studio strobes starting at the jet's nose along a 45-degree vector—like a bow wave. They are positioned about fifteen feet from the other, and triggered by PocketWizard radio transceivers set to RX. Each light has its own Buff Vagabond lithium battery power pack.. A fourth AlienBees sits at the camera (fitted with a Buff 11LTR high-output reflector for extra throw distance), and a fifth is aimed directly at the tail with some deliberate spill if there's a winglet to light. All lights are ramped up to full 640 watt-seconds power except the one aimed toward the tail. It usually needs only half power.

Nikon SB-26 strobes, mounted on PocketWizard FlexTT5 receivers at ground level, sit behind each set of wheels. They are also set to full power. Their splashes of light separate the black tires from both the darkened ramp and the airport background.

Another PocketWizard mounted on the camera's hot shoe triggers all eight lights. Its radio-based technology trips the strobes much more reliably than do light-sensitive optical devices.

During the forty minutes between sunset and nautical twilight, I vary the shutter from $\frac{1}{125}$ to as long as 30 seconds, for the widest possible range of ambient-to-strobe ratios. During early dusk, balancing ambient with strobe light can produce a very soft, flattering effect. In this shot, it helped preserve detail in the control tower at this California airport.

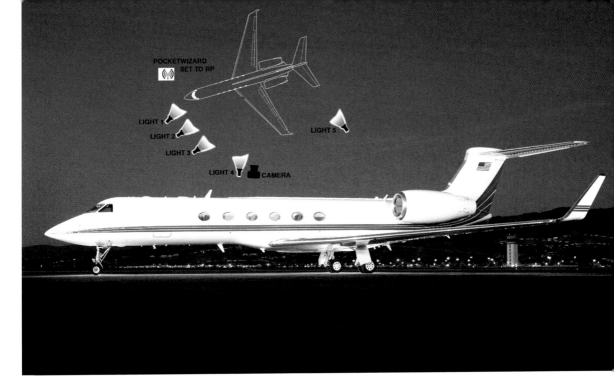

Specs: Canon 5D Mark III • Nikon 35mm PC Shift
1 second, f/8, and ISO 400

Note: Optionally, light the winglet separately by moving a strobe next to it temporarily, then make several exposures at bracketed ISOs.

Gulfstream G-V

Notes on lighting

The diagram illustrates placement of a typical five-light setup described on the previous page, and this photo shows the result. I use Dynalite studio strobe kits for hangar and indoor shoots where electricity is handy. But a few years ago I bought six AlienBees B1600s for outdoor jobs. It's a silly name for some serious strobes that perfectly suit airport location work. They are inexpensive compared to better-known brands, so it's cheap to buy spares. If a sudden wind gust or helicopter rotor downwash topples one (or three, which happened once), Buff's Nashville, TN, factory rebuilds it for far less than replacement cost.

Substituting Buff's 8.5HOR polished reflectors for the standard bowls will add one stop of light. The company's Vagabond lithium batteries easily power the AlienBees for two complete shoots—and double as portable power sources for the Dynalite packs.

I rely heavily on PocketWizard Plus III radio transceivers. They are versatile, and those unfortunate wind accidents have proven them crash proof. The units used to trigger the AlienBees are set on RX for added distance; the on-camera transmitter is set to TX for the same reason. I bought yellow versions of the on-camera and repeating units for quick identification in a time crunch. I also added PocketWizard's RT-32CTL module to my Sekonic L-358 light meter, for wireless light readings on the ramp. It guides adjustment of the strobe directions to produce even lighting from nose to tail.

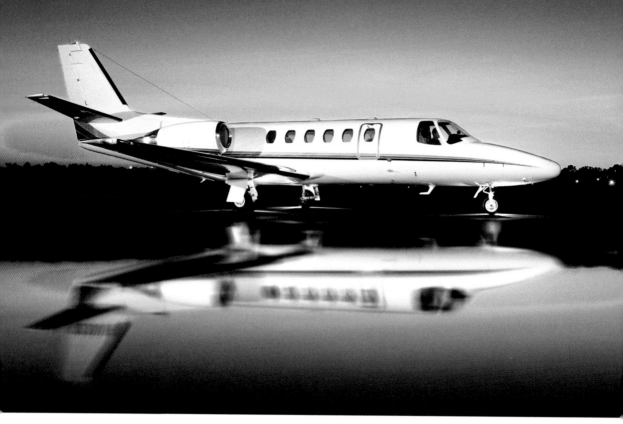

Cessna Citation Bravo

Tripods and stands

Specs: Canon 1Ds Mark II • 45mm TS-E
f/5.6, ½ second, and ISO 100

Note: Create reflections by watering the ramp,
shooting atop a mirror, or manipulating the
image in postproduction.

The perfect tripod for aviation photography has not been made. Fortunately, an almost perfect one does exist: Manfrotto's Neotec 458B. Cabins of small jets like this Citation Bravo often require placing tripod legs in awkward positions with unequal lengths. Most tripods require unlocking and re-locking three rings or levers for each leg; the 458B lets you adjust the leg's length by simply pushing and releasing a single button. It's a terrific time and energy saver. The Neotec's minimum height of four inches also makes it ideal for on-the-deck angles like this one.

There is, however, one perfect tripod head: Really Right Stuff's BH-40LR midsize ballhead. It is ridiculously expensive, but will last for years. It's also compact—a must-have in cramped spaces like a HondaJet lav. Above all, it holds position: silk-smooth to tighten and to release, but in between it's a rock.

Really Right Stuff also makes the ideal tripod/ballhead combination for placing the camera an inch or two above the ground. The ultra-compact TFA-01 Pocket 'Pod, combined with their BH-25LR, holds fifteen pounds absolutely steady. I use it to pre-position a second camera for dusk shots.

Finally, Manfrotto 1004BACs are fine light stands for jet shoots. They extend twelve feet high, yet collapse and nest with each other into a tight unit—a plus when shipping by airline. On airport ramps, I hang heavy chocks on the stands to help steady them against sudden sundowner wind gusts.

Hawker Beechcraft 900XP

Location, location, location

Location is critical. The background must be attractive, but complement rather than overshadow the aircraft. That presents a major challenge at most airports. Signs, buildings, fences, safety cones, street lamps, and other airplanes are some of the usual clutter visible beyond the ramp.

That's why most business aircraft are photographed at dusk, lit by strobes. Adjusting the shutter speed can dial the ambient light up, to show attractive detail, or reduce the clutter in an undesirable background.

As twilight progresses from lighter to darker, opening the shutter for 8 seconds at f/8 can turn a busy airport background into an attractive, brightly lit stage for the jet. Distracting elements (cones and fences, usually) can be retouched in postproduction. If the background is beyond repair, shooting at faster shutter speeds will put it into partial or complete darkness. Some clients actually prefer that stark contrast.

Avoid photographing against a hangar door; the strobes will create overlapping shadows that are nearly impossible to retouch out.

This Hawker presented an unusual opportunity: the owner offered to fly it wherever I thought it would look great. I had heard that Sedona's airport is surrounded by canyons that glow red at sunset, so we hauled my camera and lighting cases onboard and headed there. While he went into town for dinner, I made a strobe-lit series of photos as the sun's last rays hit the tall canyon walls.

Specs: Canon 1Ds Mark II • 45mm TS-E
4 seconds, f/8, and ISO 200

Note: My lighting often spills onto the foreground. Barn doors would control it, but I prefer darkening it with postproduction gradients.

Gulfstream G550

Using Canon TS-E and Nikon PC lenses

Perspective control lenses are terrific tools. If I had any trade secret, this would be it. Introduced by Nikon in 1962, they allow photographers to capture accurate perspective; the lens can be shifted parallel to the sensor to provide the same corrections as a much larger view camera. Architectural photographers use them while photographing tall buildings without tilting the lens, to avoid converging lines that make a building look like it's leaning backwards. While convergence is less noticeable in jet photos, the brain isn't fooled. Subliminally, something just looks wrong.

I use modern Canon 24mm and 45mm TS-E ("Tilt Shift-Electronic") lenses, along with vintage Nikkor 28mm and 35mm PC ("Perspective Control") glass. The two Nikkors have adapters to fit Canon EOS cameras; lacking compatible electronics, they default to manual aperture settings and manual focus. Using them is a delightfully old-fashioned process.

Still, I appreciate the Canon 45mm TS-E's ease of use. Its fast f/2.8 aperture makes it an ideal choice for low-light dusk shots like this one. I began by choosing an angle that included the G550's nose and horizontal stabilizers. I sat the camera on the ground low enough to reveal both sky and the distant mountains. Then I used the camera's electronic viewfinder level, splitting the frame so half of it was below the horizon and half above it. The final step was to twist the control knob that shifts the front elements vertically. The perspective stayed true, but now the frame included more of the rich blue sky while cropping out a large swath of uninteresting ramp in the foreground.

Specs: Canon 1Ds Mark III • 45mm TS-E
2 seconds, f/5.6, and ISO 200

Note: A dark blue gradient was added to the sky in post production, along with a black gradient to the foreground.

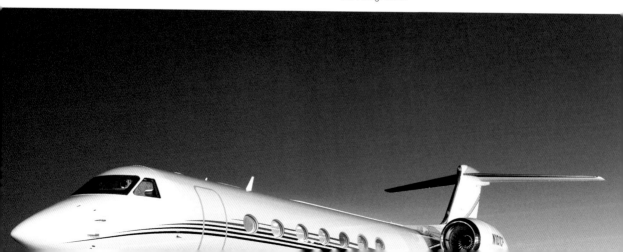

Specs: Canon 1Ds Mark III • Nikkor 28mm PC
30 seconds, f/5.6, and ISO 200

Note: I lit the winglet separately for a few shots, to add later in postproduction. I should have also lit the number two (right) engine.

Boeing Business Jet

Three lights, 1200 watt-seconds, and one very large jet

This was the first Boeing Business Jet ("BBJ") I photographed; I was lucky it wasn't my last. At that early career stage, I was lighting dusk shots with a trio of battery-powered Norman 400B strobes. It was not a fair fight. The first test exposure immediately proved that the usual formula of 4 seconds at f/8 at EI 100 with the Canon 45mm TS-E lens wouldn't work—there was no way to position those puny lights close enough to the jet to have any effect without showing up in the frame.

The solution, I finally realized, was to gamble with the pilot's patience and wait for the dusk sky to get almost full dark. Those Normans may have been 400 watt-second weaklings, but they could recycle back to full power very quickly. By manually triggering them the instant they recycled, it would be possible to build up the light by firing multiple strobe "pops" during a long exposure.

I began by swapping the 45mm lens for a Nikkor 28mm PC, permitting the camera and lights to move in much closer. The wide-angle 28mm has great depth of field; setting its aperture to f/5.6 carried focus from the winglet to the fuselage. I positioned one strobe near the nose, another at the camera, and the third by the tail. The best exposure, 30 seconds long, provided enough time to trigger the flashes six times with a handheld PocketWizard transmitter. Through sheer luck, it was also the perfect exposure for the windows.

Quest Kodiak 100

Creating two airplanes from one in postproduction

Specs: Canon 5Ds • 24mm TS-E
f/16, ⅟₃₀ second, and ISO 100

Note: The Kodiak was designed as a rugged airplane for missionaries to deliver religion and relief supplies to remote, emergency-stricken areas.

When Clay Lacy Aviation began selling Quest's brawny Kodiak 100, Lacy had one airplane on hand—but for marketing purposes, wanted to show two. Lacy also requested a composition that would work well as either a horizontal or a cropped vertical. And they needed some empty space to overlay advertising copy.

The solution seemed simple: lock the camera into position, photograph the plane in two non-overlapping positions on the ramp, and combine them in postproduction.

And it almost was that simple. We started with the aircraft placed on the right, then adjusted camera height to emphasize the overhanging wing without hiding the Lacy sign with the propeller blades. Using the view-finder's screen lines, I noted exactly where the airplane's blades ended. The ultrawide 24mm tilt/shift lens was set at f/16 to carry deep focus, and shifted vertically to get maximum sky without cropping out the wheels. I then made a 7-stop series of bracketed shutter speeds.

To keep the sun angle constant, we had the line crew immediately move the aircraft to camera left. That part worked perfectly. But in the 5 minutes it took to shift the plane, a long cloud slowly drifted across the sun. What was strong clear light became considerably softer and mushier. Fortunately it was possible to match color and contrast in postproduction.

Rather than remove the "N" number, I reserved a nearly identical "N" number through the FAA and retouched that in.

Beechcraft
Super King Air B200

Mixing continuous and strobe lighting to produce full propeller arcs

Propeller-driven aircraft require a bit more work when photographed with strobe lighting at dusk. If the props are stopped, the lights throw multiple shadows across the fuselage from, in the case of King Airs, four blades on each engine. That produces a very amateurish look.

It's a much more dynamic shot when the props are spinning. Strobe lights, though, freeze the blades and still cause shadows. To catch a full arc, the propellers must be lit with strong, continuous lights. And if the engines vibrate, they'll shake the plane during long exposures, producing a ghosting effect.

Fortunately, this B200 was perfectly maintained and rock steady. I brought a rented Honda generator and plugged in four 1000-watt tungsten Lowel Tota-lights filtered with Rosco's full CTB (Convert-To-Blue) gels. Positioned just off-camera and aimed directly at the engines, they lit not only the blades but also the number 2 (right) engine nacelle. That made the four blades into a smooth 360-degree circle that seems to shimmer.

Nonetheless, the four Norman 400B strobes threw multiple shadows along the fuselage, particularly towards the nose. Lots of postproduction time went into cleaning them up.

Further complicating the shot, King Airs have unusual, rotating polarized window inserts at the seats instead of shades. They are very dark; it took a separate 60-second exposure to get even the minimal window glow seen here.

Specs: Canon 5D Mark II • 70-200mm at 130mm f/6.3, 8 seconds, and ISO 200

Note: King Air variants have been in continuous production since 1969; over 6,000 have been delivered.

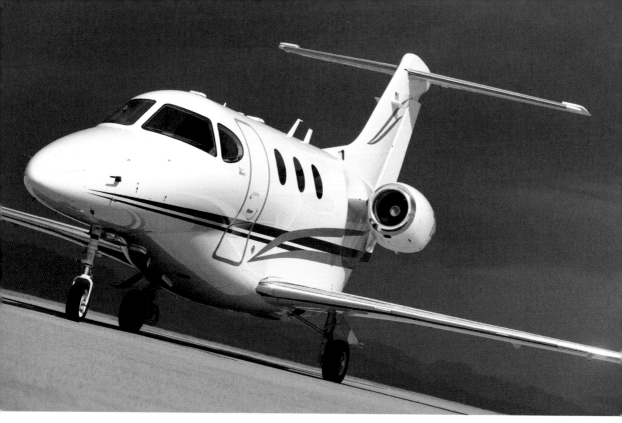

Hawker Beechcraft Premier 1

Tilt and telephoto transform the ordinary

Specs: Canon 1Ds Mark III • 70-200mm f/7.1, $^1/_{640}$ second, and ISO 100

Note: The tan ramp reflected beautiful light into the Premier's belly, but it was too yellow and had to be masked and desaturated.

Dusk shots are wonderful, but sometimes schedules, or in this case a threatening thunderstorm, force the exterior to be photographed in daylight—quickly.

The Premier 1 is one of the earliest single-pilot private jets, and the first with a carbon graphite epoxy fuselage—the same lightweight composite material that Boeing chose for its giant 787 Dreamliner series. The seamless composite surfaces make it a delight to photograph.

It seems to sit on a desert here, but it was shot at Mesa-Gateway Airport, near Phoenix, Arizona. The ramp's color is naturally light tan, a good complement to the blue in the sky and mountains.

I chose a telephoto lens to foreshorten the jet; a close, wide-angle lens would have been cruel to the narrow nose and wide underbelly. I took standard shots with the entire aircraft in frame, and the wings level. Strong patches of light made the bright jet look crisp against the background. But it was a static, boring composition. Tilting the camera, and zooming in with the telephoto, transformed it into a more dynamic diagonal image. Just out of camera frame, the pilot angled a silver Photoflex reflector to kick some sunlight into the engine inlet.

The ramp and the mountains were lightly retouched to remove some distracting elements. Both the tan and blue colors have been gently deepened using Photoshop's HSL adjustments.

Dassault Falcon 2000EX

Perfect window glow, practically guaranteed

Business jets that turn heads are said to have ramp presence. Spectators want to see what kind of person steps out of them when the stairs come down. This Falcon's black paint with white pinstripes is bold without being brash. The effect is, paradoxically, both loud and dignified. This airplane has ramp presence to spare.

This photo succeeds for several reasons. The black stands out against the orange horizon and gradated blue sky. The stripes lead the eye easily from the nose to the bright engine blades, which were light painted with a Pelican 7060 tactical flashlight. The fuselage looks glass-smooth because all seams, rivets, and protuberances were laboriously removed in postproduction.

But it's the window glow that makes this aircraft, and others photographed at dusk, look inviting. It begins with locking down the camera and tripod. All lights are then turned on in the cabin—reading, table, upwash, downwash and galley. For large jets, that requires running the APU or an engine. For small aircraft like Citations, five minutes using battery power is an alternative. In the cockpit, I fit a Westcott Ice Light with a full CTO gel, and then lay it lengthwise across the throttles, turned on to full power. Back at the camera, I shoot a series of "plates" without the strobes, bracketing the shutter speeds from 1 to 30 seconds in one-stop increments. In postproduction, the best window and cockpit exposures can be blended into the best strobe exposure, and the yellow glow's saturation dialed up or down as needed. If one window looks too dark, clone in the glow from another pane.

Specs: Canon 5D Mark III • 45mm TS-E
f/8, 2.5 seconds, and ISO 400

Note: Ordinarily, passenger jets are painted white to reflect heat; fluid leaks, corrosion, and cracks are also easier to detect against a bright surface.

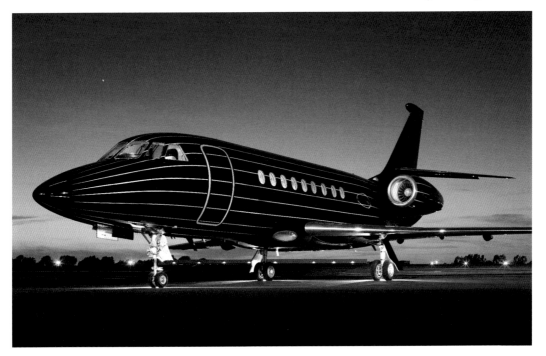

Cessna Citation CJ3

That trendy desaturated, high-contrast portrait look

Desert Jet, a multifaceted company tucked away in California's hottest desert, likes their charter aircraft photographed in full sunlight, with plenty of stark terrain in the background. That visual signature distinguishes the company's marketing from the many firms who use strobelit dusk photographs.

After making the assigned profile image of their Citation CJ3, I walked progressively closer and shot progressively wider. Photographers rarely show the aft end of jets, so it was a chance to try something out of the ordinary. Earlier that day, I had photographed the company's new employees. Again to differentiate their branding, Desert Jet always requests that those portraits be desaturated to an almost monochromatic, warm-toned final look for its web site. I wondered what that technique would look like, highly exaggerated, if applied to the CJ3. It's been a trendy look for magazine and advertising shots, especially to illustrate high-energy fitness and sports personalities.

So here's the result when the high-energy personality is a private jet. All modifications were done in Photoshop's Camera Raw by just moving a few sliders. Step by step, the adjustments were: (1) Color Temperature warmed from 5700 to 7700 degrees; (2) Contrast raised to +100; (3) Shadows increased to +100; (4) Whites raised to +50; and (5) Vibrance decreased by –75. The Desaturation slider, an obvious choice, produced too much edge haloing where the jet meets the sky.

After cleaning up some pebbles on the ramp and buildings in the back, the image was finished.

Specs: Canon 5D Mark III • 24–105mm at 32mm
¼₀₀ second, f/11, and ISO 100

Note: Used CJ3s are widely regarded as having the best value of Cessna's long line of CJs; they have an ideal combination of speed, range, and capacity.

BAe Hawker 800A

Composing the billboard shot

Side views earned the nickname "billboards" because they serve the same purpose. They are easy to take in, and they provide a lot of visual information at a quick glance.

The Hawker 800A is a small jet; it took only three Norman 400B strobes to light the fuselage, and three Nikon SB-26s behind the wheels to separate out the black tires. The sky provided a glorious sunset, best captured by a short $\frac{1}{30}$-second exposure instead of the usual eight seconds.

Most of my billboard shots are composed like this one. Using the classic Rule of Thirds, the jet occupies the center third of the frame, the sky the top third, and the ramp the lower third. The extra space lets clients crop in, add sky on top or ramp at the bot-

tom, or drop in text if desired. The winglet aligns with the horizontal stabilizer to make a pleasing parallelogram.

The camera's slightly ¾-angle placement ensures that the winglet doesn't overlap with the tail fin. It also gives a clear view of all three bogies (a bogie is a landing gear arrangement with two or more wheels). The low camera placement separates the jet from the backdrop and adds drama. Finally, a slight vertical adjustment of the tripod brought the fuselage paint stripes into perfect alignment with the nacelle stripes.

The heavy black gradient along the bottom frame keeps viewer eyes on the plane, but also hides a very damaged ramp surface.

Specs: Canon 1Ds Mark III • 45mm TS-E
f/5.6, ⅓₀ second, and ISO 200

Note: I never decided if the red taxiway signs add to the photo or detract; they probably keep the background from looking like a paper cutout.

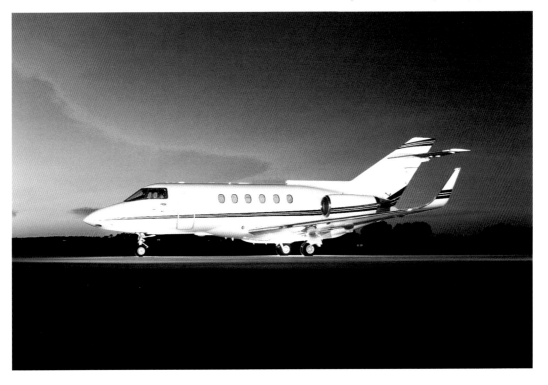

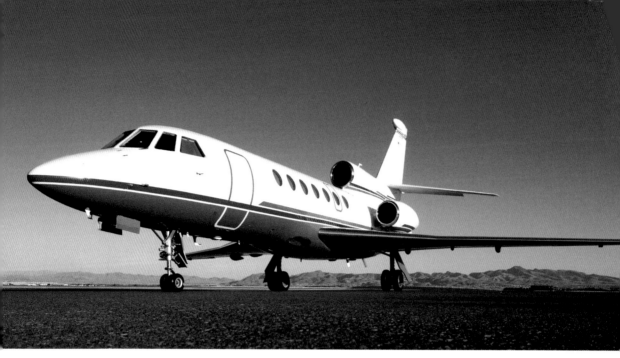

Specs: Canon 1Ds Mark II • Nikkor 35mm PC
¹⁄₂₅₀ second, f/16, and ISO 100

Note: Pilots love the Falcon 50. One pilot writes that,
"You feel it. It seems vacuum packed around you,
like a custom driving glove on the hand."

Dassault Falcon 50

Wide, low, and shifty with the world's most photogenic private jet

For decades, France's Dassault Aviation has turned out sleek fighter jets that are as beautiful as they are fast. The same aesthetics carried over to their business aircraft designs. Although it dates to the mid-1970s, the company's Falcon 50 still looks gorgeous. The three engines, the cockpit's seven atelier windows, and the pronounced stabilizer anhedral together make the jet stand out. It has no bad angles. It is, by far, my favorite executive jet to photograph.

The locale looks isolated, but it isn't—this is McCarran International Airport in Las Vegas, Nevada. The camera's position inches above the ground, and the sun's low crosslighting, exaggerated the ramp's pebbly texture to give it a parched desert feeling. A number of distracting buildings and parked jets were retouched out, for a visually uncluttered background.

This was the first time I mounted a Nikon lens onto a Canon body, back in 2005. Canon no longer made 35mm focal length shift lenses, so I used a custom adapter to fit a Nikkor 35mm f/2.8 PC (for Perspective Control) to my Canon 1Ds Mark II. Lacking electronic "handshake" contacts, the lens and the camera revert to completely manual modes. It's a small price to pay for the chance to use one of Nikon's sharpest and cleverest lenses. It was a quick setup: I lay on the ground, leveled the camera on my camera bag, and shifted the lens up. PC lenses typically vignette when shifted towards extremes. That produced a natural, pleasing sky drop-off without any postproduction gradient filter.

Dassault Falcon 50

Visually separating dark tires from a dark ramp

My favorite business jet again, photographed at dusk this time, with the default eight-strobe setup to light the fuselage and undercarriage.

Photographing black tires against the dark ramp during a rapidly darkening twilight presents a challenge. It's difficult to see them. Most business jet photographers solve the problem the same way: backlight the three sets of wheels with one large or three small strobes. I'm no exception. I use three vintage Nikon SB-26 strobes bought cheaply on eBay. Set on full manual power, each one sits on a PocketWizard FlexTT5 that receives the triggering signal from the camera's PocketWizard transceiver.

The SB-26s recycle back to full power in just five seconds.

But since the camera is usually positioned just inches above the ground for evening shots, there's a problem getting the SB-26s to flash: radio transceivers perform poorly when set low on large expanses like airport ramps, and their signals don't penetrate thick metal objects like landing gear struts.

The solution? Another PocketWizard, set on RP/repeat and perched atop an 8-foot high light stand. I stationed the stand just off the jet's nose, out of camera view, with direct lines of sight to both the camera and the three flashes hidden behind the wheels. The extra transceiver solved the problem of intermittently firing wheel flashes that had vexed me for years. Technical staff at PocketWizard suggested the workaround; it's a reminder that photographers shouldn't hesitate to use the human technical resources that companies offer professionals.

Specs: Canon 5D Mark III • 45mm TS-E
2 seconds, f/5.6, and ISO 200

Note: I use Eneloop Ni-MH rechargeable AA batteries in all PocketWizards and SB-26s. They are powerful, economical and environmentally friendlier.

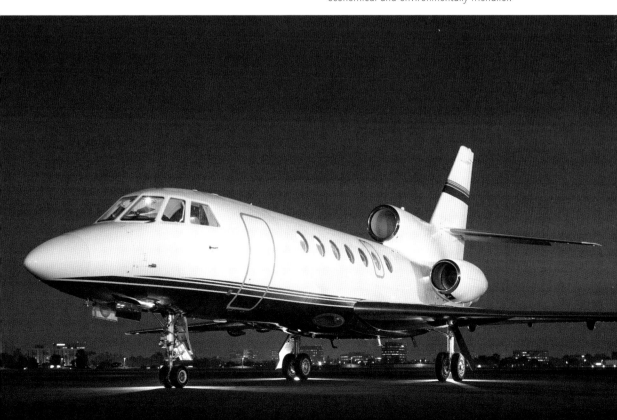

De Havilland Canada DHC-2 Beaver with Harrison Ford

Photographing aviation personalities

Aviation photography encompasses the industry's entire spectrum. Aircraft are its centerpiece, but developing the ability to light and direct people broadens a photographer's power to attract assignments. Early in the photojournalist phase of my career, I photographed executives for a number of business magazines. The experience helped me develop a strong portfolio of editorial portraits.

It paid off when 6,000-hour pilot Harrison Ford volunteered to chair the Experimental Aircraft Association (EAA) Young Eagles program. *AOPA Pilot* magazine assigned me to make publicity photographs for the announcement. "Don't get all Hollywood on this," his personal assistant counseled. "He's really a regular guy." And he was; he pointed out his house when we flew over it.

The de Havilland Beaver behind Ford is his signature aircraft. Its cheerful colors and imposing radial engine offered the perfect portrait backdrop. I positioned a large 6-foot umbrella to his left, fitted with a diffuser, to wrap soft light around both him and the cowling. A 1/4 CTO (Convert to Orange) gel on the Dynalite strobe added a touch of believable warmth. To his right, a 42x68-inch silver Sunbounce reflector kicked fill light into his face and the radial engine. Behind him, an open hangar door splashed some light onto the Beaver's rear fuselage.

He brought several changes of wardrobe, but I selected the black shirt to lead viewer's eyes to the brightest part of the photo—his face. Like so many pilots, he drinks a lot of coffee; in postproduction, I whitened his teeth. Also in post, I removed hangar clutter and my own image from the propeller spinner.

Specs: Canon 1Ds Mark III • 70-200mm at 95mm f/5.6, ½₀ second, and ISO 100

Note: This was the rare time I hired an assistant, to act as a stand-in and help me quickly light three different sets. Money well spent.

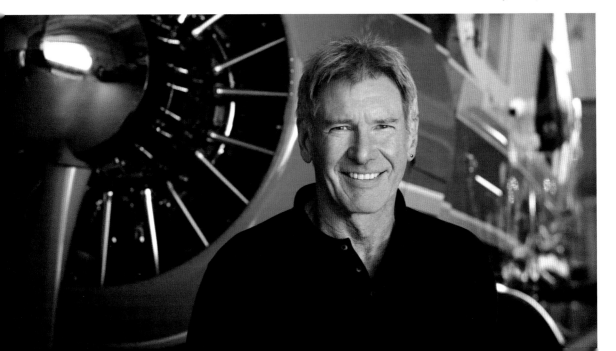

Grumman E-2C
Hawkeye 2000
with Naval Flight Officers

Using tinted gels to add color

For a story on the E-2C Hawkeye early warning & battle management aircraft, I needed a photo of the three Naval Flight Officers (aka Operators) wedged into the dark, narrow fuselage along with racks of electronics and computer monitors. There are no windows; illumination had to come from the monitors themselves, task lighting, and whatever tiny sources I could wedge into corners. The fast 20mm f/2.8 lens helped by opening up the small space, and made manual focusing (on the middle screen) easier.

Everything is painted gray on Navy airplanes. Fortunately the monitors added blue, the tungsten task lights added yellow splashes, and the ceiling turned green where those colors overlapped. To add a dominant visual wash of color, I taped a red gel over a Canon 580 flash set at ½ power, and triggered it manually while held above and to the right of the camera.

It took a 4-second exposure to register the panel lights and blue glow on crew faces. That overexposed the monitors, so I made a series of bracketed time exposures. By holding a constant f/5.6 aperture and keeping the camera rock steady on a tripod, I could later drop properly exposed screens into the final image in postproduction. Amazingly, the crew held still for even the longest four-second exposures.

Specs: Canon 1Ds Mark II • 20mm
 4 seconds, f/5.6, and ISO 400

Note: E-2C pilots brag they'll beat any jet to 5,000 feet off the catapult—a boast backed up by the Hawkeye's enormously powerful 5100 shp engines.

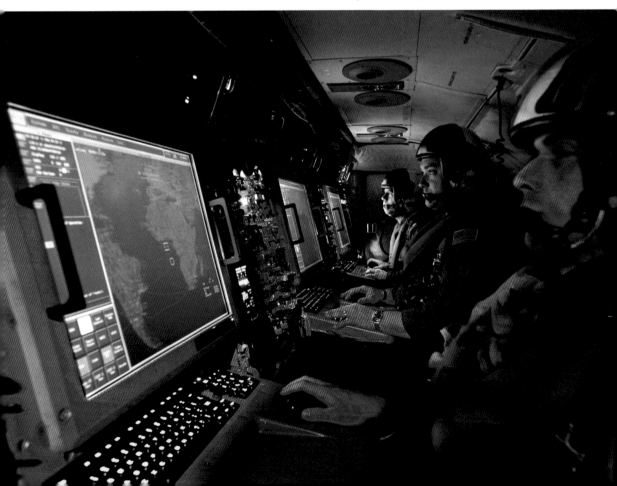

Learjet 25B with Aerial Director Kevin LaRosa II

Lighting design with mixed strobe modifiers

AOPA's publications like to spotlight member pilots who have unusual histories, skills, or occupations. This is aerial director and Learjet 25B pilot Kevin LaRosa II (aka K2). He's terrific at both flying and directing. When I proposed to write and photograph a short piece on him, *AOPA Pilot* magazine assigned it.

The art directors there encourage photographers to surprise them with looks they've never seen before. Both Kevin and the Learjet are photogenic. Neither needs diffused lighting to soften wrinkles. It offered the perfect opportunity to pull out some crisp, hard-edged lighting tricks.

To make the jet loom dramatically behind Kevin, I chose a zoom lens racked out to 400mm. With the lens wide open, he was sharp while the jet went slightly soft for a pleasing backdrop. The sides of his face are backlit by two AlienBees positioned behind him at 45-degree angles. Their spill light also lit the jet's nose. Two other AlienBees, positioned at his sides but facing backwards, lit the wings and engine inlets. Kevin was lit by a Dynalite M1000X watt-seconds studio power pack and Dynalite 2020 strobe head positioned high above the camera. It was fitted with a 10 degree honeycombed grid spot to prevent overpowering the backlighting that defined the sides of his face.

A Dynalite M1000X power pack with Dynalite 4040 domed, cyan-gelled strobe head added the final touch. It stood behind the Lear's tailcone and pointed backwards, to paint the hangar wall and floor with a soft blue wash that contrasted with K2's warmed face (with a ½ CTO gel).

Specs: Canon 5D Mark III •
 100–400mm at 400mm
 f/6.3, 1/125 second, and ISO 400

Note: Kevin's advice to new pilots, "Fly without a noise-canceling headset. Listen to the plane; it's always talking to you."

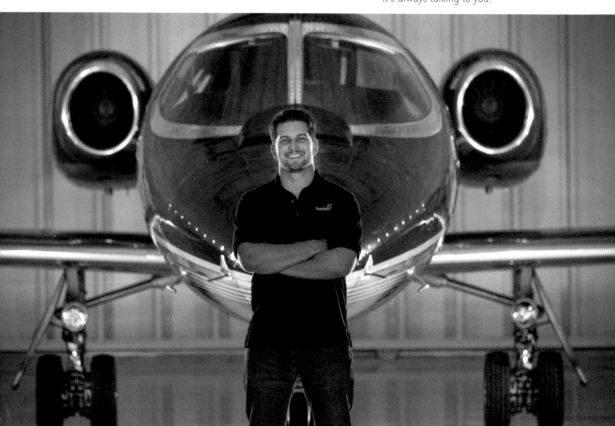

Scaled Composites SpaceShipOne with Astronaut Brian Binnie

Using an architectural lens for a cover portrait

On October 4, 2004, test pilot Brian Binnie flew SpaceShipOne (SS1) to a record altitude of 367,442 feet (69.6 miles) to claim the Ansari X-Prize as well as astronaut wings—and $10 million for investors.

Air & Space/Smithsonian magazine assigned me to make a cover photo to accompany his first-hand account. Covers are vertical; SS1 is horizontal. To help fill the extra cover space, I asked Scaled Composites technicians to actuate the hydraulics that deployed the tail feathers to their vertical reentry configuration. A strong Dynalite M1000X studio strobe added fill light

to the fuselage; a Norman 400B strobe added fill to Brian's left side. I mounted a Nikon 35mm Perspective Control lens with an adapter onto a Canon camera. Shifting the lens vertically let me vary the sky-to-ground ratio, while avoiding the "keystone" distortion to Brian and the spaceship that tilting the camera would cause. The additional sky made room for the magazine's masthead and cover lines.

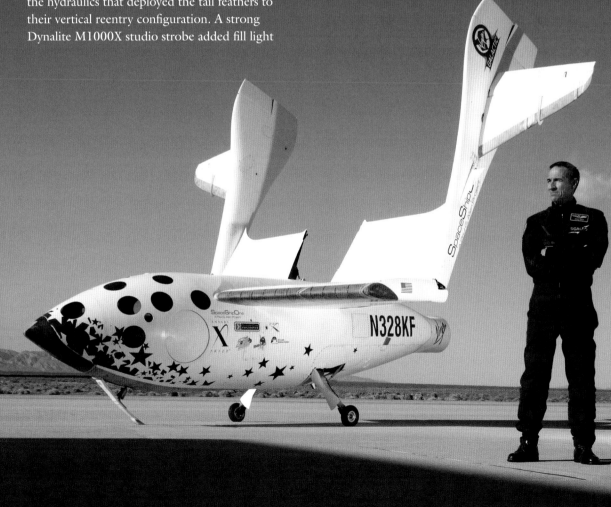

Specs: Canon 1Ds Mark II • Nikkor 35mm PC
½₅₀ second, f/11, and ISO 100

Note: It took Binnie an (uncomfortable) hour to hitch a ride to launch altitude, but only ten seconds to go supersonic after the drop.

Curtiss P-40N Warhawk with Steve Hinton

Reflecting light into a speed demon's office

Steve Hinton's full resumé would fill most of this book. The short version includes 7,000 hours piloting warbirds; President of the Planes of Fame Air Museum; founding member of the Motion Picture Pilots Association; owner of Fighter Rebuilders LLC; flight time in more than 150 different aircraft types; countless peer awards; movie stunt pilot; thirty-five-plus years performing in airshows; world speed record holder; and especially, six-time Reno Air Race champion in the no-holds-barred Unlimited Gold class. This man could wring speed out of a toaster.

AOPA Pilot assigned me to photograph Steve as part of its feature on the Planes of Fame Air Museum. If you're not a piston or a turbocharger, there's not much time in his schedule for you. When I arrived, he suggested a quick air-to-air shot of him in a Curtiss P-40N he was restoring, and told me to go strap into the nearby Douglas SBD Dauntless while he scrounged up a pilot for it.

It was a great flight that produced wonderful photos, but the magazine still needed a close-up portrait. Quickly, of course; Steve needed to dive back into the P-40N after we landed. There was no time for fancy lighting. I mooched enough time to go grab a 4x6-foot silver Sunbounce reflector from the car. A makeshift assistant used it to direct the late, low sunlight towards the cockpit, where it perfectly lit Steve's face. It was a fast lighting solution for a busy man who appreciates speed.

Specs: Canon 1Ds Mark II • 70-200mm at 200mm
½₀₀ second, f/5.6, and ISO 100

Note: Silvered reflectors are versatile but so bright that subjects will involuntarily squint if hit directly with their light; use them sparingly.

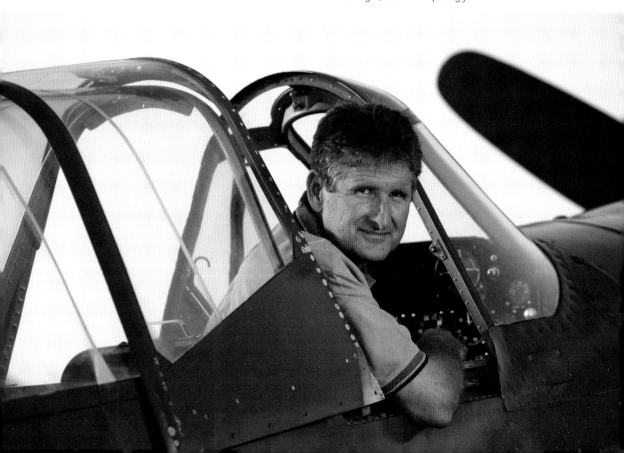

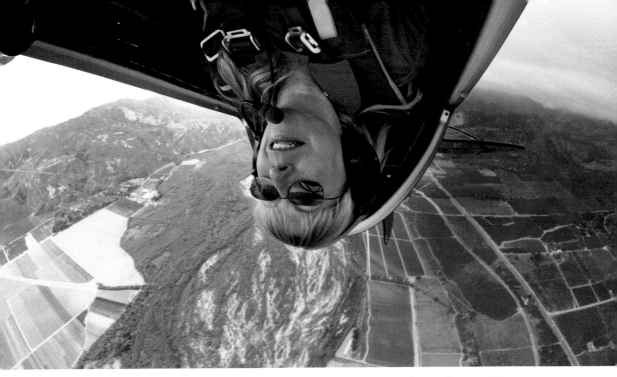

Pitts S-2B Inverted with CFI Judy Phelps

Specs: Canon 5D Mark III • 15mm semi-fisheye f/9, 1/160 second, and ISO 400

Note: For clearest transmitting, pilots put the headset's microphone at their lips; but for photos, the mike must be lowered to see faces.

Remotely triggering a cockpit camera

Upside down and heels over head over head—for Judy Phelps, redline is a goal, not a limitation. The 7,000-hour pilot and FAA Instructor of the Year flies aerobatics between teaching duties. *AOPA Pilot* sent me to photograph her for one of its monthly pilot profiles.

We made the obligatory ground portraits, but then realized: she belonged in the air. Her Pitts S-2B was the perfect platform, with its large bubble canopy letting in lots of light. Husband Clay Phelps quickly cobbled together a bracket to hold my camera. I chose a 15mm semi-fisheye lens. The lens barrel was focused manually at three feet and then taped to prevent slippage during violent maneuvering.

Aiming the camera directly at her minimized distorting her face yet gave a nice round earth behind her. The sky showed about 80 percent overcast. I guessed that setting the camera at f/9 and Av (aperture preferred) mode would hold both focus and sharpness in any light condition.

I am not aerobatics-hardened; Judy would have to take selfies during the photo flight. We set a PocketWizard Plus III to Receive mode and connected it to the camera's remote control terminal with a Canon RS-80N3 cord. I gave Judy a second PocketWizard, set to Transmit, with instructions to hold it out of sight while pressing the button non-stop. I also asked her to smile during the entire flight. "I'm always doing that anyway," she laughed. She wasn't kidding. In her 25-minute, high-performance aerobatic flight she triggered 1,145 photos. She is grinning in over 1,000 of them.

Cary Grant's Convair 240 with Chelsea Dawson

All that's fair must fade

In the late 1940s, at the request of American Airlines, Convair designed the Model CV240 passenger transport to replace the aging Douglas DC-3. This one, construction number 93, began life in 1948 with Trans-Australia Airlines. By 1970 it had flown for two more airlines and one corporation.

In September of that year, Fabergé bought it for movie idol and new spokesman Cary Grant. Re-registered as N396CG, it sported a piano in back and often flew Grant's Rat Pack buddies (Frank Sinatra, Dean Martin, Sammy Davis, Jr., Peter Lawford, and Joey Bishop) between Los Angeles and Las Vegas. After Grant moved up to a jet, the plane passed through a number of airlines and owners. Finally, it came to rest at California's Camarillo Airport, bought by an individual intent on restoring it back to the Cary Grant days.

That's where I saw it. I'd been searching for an unusual airplane to photograph for my annual New Year's card. After getting permission from the owner and the airport, I called Chelsea Dawson and asked her to dress like a steampunk-era time traveler who had stumbled into the 1940s. Two AlienBees strobes with standard reflectors added fill light to the airplane, while a third strobe—with a specular silver reflector—kicked harder light onto Chelsea's face. Lens choice was again the Nikon 35mm Perspective Control; shifting it vertically added more sky without distorting either Chelsea or the Convair. The airport was later "restored" to the 1940s with a lot of retouching.

No matter how handsome or rich or famous one is, time always catches up. This is the photograph that keeps me grounded. It's a daily reminder: all that's fair, must fade.

Specs: Canon 5D Mark III • Nikkor 35mm PC
⅟₅₀ second, f/16, and ISO 100

Note: The low sun didn't backlight the cockpit windows, so I placed a strobe fitted with a full CTO (orange) behind the cockpit, then retouched it out.

Cessna Citation Excel with Kristin Gilliam

Specs: Canon 5D Mark IV • 70–200mm at 135mm f/2.8, 1/800 second, and ISO 800

Note: Hard-learned lesson: when using long lenses on a tripod, turn off image stabilization options to avoid blurriness from feedback loops.

Steampunk meets turbofan in the Sonoran desert

This photo took five minutes to shoot, then five hours to refine in postproduction. Everyone loved the New Year's card with Chelsea and Cary Grant's plane. Cool plane, model with vintage suitcase, and steampunk props: that would be the annual motif going forward.

Kristin Gilliam volunteered to be the next year's model. Denise Wilson volunteered a Desert Jets Citation Excel. The Excel's pilot volunteered to thrash us all if we bent his wing. We promised to perch Kristin at a strong spar, and to put down a thick mat to protect the plane.

We began shooting fifteen minutes before sunset, with lots of poses and different props. The desert sky became a huge softbox as dusk rolled in; I never needed the umbrella fill light I'd brought.

But the light was blue and flat. Some of the photo's elements were too bright (the sky) and some, too dark (the parasol). So using Photoshop, I saturated the suitcase color; saturated the orange in the sky and the blue in the wing; opened up detail in the engine inlet to highlight the fan blades; removed reflections in the engine nacelle; pumped shadow detail into the parasol; adjusted the exposure in Kristin's face, glasses, and hat; warmed her skin tones; removed wrinkles and bulges in her dress; and, added a gradated blue filter to the sky; and finally, retouched out the protective mat. In postproduction I sometimes got down to the pixel level—especially while adjusting the parasol.

The search has just started for next year's amazing airplane and steampunk model.

Grumman Gulfstream II with John Travolta

Getting tilted with a movie star pilot

Professional Pilot magazine assigned cover and inside photography of actor and high-time pilot John Travolta. He positioned his crew in front

Specs: Mamiya 645AFD • 150mm
Fujichrome 220 Provia II
1/500 second, f/8, and ISO 100

Note: NASA used four modified GIIs to simulate space shuttle landings. Software and identical cockpit controls exactly duplicated the orbiter's feel, described as a very heavy glider and a flying brick. Every pilot and mission commander made at least 1,000 GII flights.

of his Gulfstream, stepped in front, and insisted this was the cover. I made the shot, it was boring, and of course, it became the cover. But I also asked him to pose on the wing. He said it was a terrible idea but did it; a year later he leased this image as the author photo for his new children's book.

To add drama, I tilted the camera but left space on top for the magazine title. Two Sunbounce silvered reflectors filled in the deep high-noon shadows on his face and the engine blades.

Bill Hardy,
Ace in a Day

Improvising an outdoor studio

On any given Wednesday, between fifty and seventy pilots drop in to a Denny's restaurant in Oceanside, California for an informal breakfast. The Old, Bold Pilots, they call themselves, and *Air & Space/Smithsonian* assigned me to photograph some of them. I'd long wanted to do a series of portraits as homage to photographer Richard Avedon; for his landmark book *In the American West*, he hung white seamless paper on shaded outdoor walls and picked out intriguing people to photograph. With editor Caroline Sheen's help, we did the same at the Denny's. To reflect the sense that the pilots' histories are fading and need to be saved, I desaturated the photos and added in some contrast during postproduction.

Specs: Canon 1Ds Mark III • 24–105mm at 105mm
$\frac{1}{250}$ second, f/5.6, and ISO 400

Note: Willis "Bill" Hardy (1920-2017) holds helmets he wore flying piston fighters in WWII, and in early jets during the Korean conflict. A pilot earns the accolade "Ace in a Day" by waking up one morning and then scoring at least five kills by midnight. Hardy did that on April 6, 1945, downing five Japanese aircraft in just 70 minutes from his Grumman F6F Hellcat.

Grumman F-14A Tomcat Pilots with Christine Fox

The accidental Top Gun cover

Jerry Bruckheimer's 1986 hit film *Top Gun* featured a Navy F-14 pilot (played by Tom Cruise) and his love interest (Kelly McGillis). When I read that McGillis's role was based on a real-life military analyst, I suggested to *Air & Space/ Smithsonian* that it should feature her. Christine Fox turned out to be tall and blond like McGillis's character, but a very shy mathematician who liked to sail and knit. I surrounded her with six F-14A crew members from VF-213, the Black Lions, on an outdoors stand, thinking it would make a fun story opener. The photo editor loved it and instead chose it for the magazine's cover. A nearly identical photo— but with helmets off—did wind up running as the story opener. Years later, Ms. Fox became the highest-ranking woman ever to work at the Pentagon.

Specs: Nikon F5 • 105mm Fujichrome 35mm Provia (film)

$1/60$ second, f/5.6, and ISO 100

Note: Publicity-shy by temperament, Fox agreed to the story to inspire girls to study the sciences.

North American T-6 Texan with Rachel Carter

Four lights, one heart, and the FAA

At age nine, Rachel Carter became the youngest pilot to fly round trip across the lower 48 states. Ten years later, she had two heart valves replaced; the FAA responded by denying her a third class medical certificate. She was deep into the appeals process when *AOPA Pilot* asked me to photograph her for its Debrief page. I bought this medical heart model and asked Rachel to wear a black top to make it stand out. A friend volunteered a T-6 for the background. This portrait is a four-light photograph. One bare-bulb Norman 400B, covered with a deep blue gel, lit the engine pistons behind her. Two Norman 200Bs, fitted with small Chimera softboxes, stood just off each elbow to light the cowling. The hard "butterfly" lighting on her face comes from a Norman 400B covered with a narrow-angle grid spot.

Specs: Canon 1Ds Mark III • 70–200mm at 90mm f/5.6, ¼ second, and ISO 100

Note: Rachel subsequently underwent open heart surgery, got her FAA medical certificate back, and earned her private pilot license.

Northrop Grumman F/B-23 Concept with Brittany Belt

An homage to vintage aviation pinup photography

Inspired by a 1950s black-and-white pinup photo of actress Lee Patrick holding a model of Northrop's Snark missile, I decided to attempt an update. I'd keep the same sexy innocence but swap out the vintage missile with a once-secret stealth bomber concept. Tony Chong provided the F/B-23 model, Zenna Hodges provided period-perfect hair & makeup, and actress Brittany Belt provided an abundance of all those things that make a pinup beautiful. Glamour photographers didn't have softboxes back then, so I used unmodified lights with no attempt to hide shadows. I did cheat by using three Dynalite M1000X power packs and three model 2040 flash heads instead of continuous tungsten lights. The key light came from my left, the fill light from my right, and a snooted strobe, positioned high on the left, lit Brittany's face.

Specs: Canon 5D Mark III • 24-105mm at 70mm ⅟₁₂₅ second, f/20, and ISO 100

Note: The classified F/B-23 concept was inadvertently revealed when this model showed up on eBay. It had been stolen from Northrop Grumman's model shop by a contractor.

Xaero Rocket with David Masten

Five lights, four gels, and one rocket

For a story on the independent rocket entrepreneurs scattered across California's Mojave Desert, *Air & Space/Smithsonian* magazine assigned a portrait of Masten Space Systems founder David Masten. His Xaero rocket luckily had its shrouds off when I arrived, but the only uncluttered space to photograph it was against a rollup door. I lit the door with a blue-gelled bare-bulb Norman 400B, clamped (carefully) onto Xaero's hidden side. A yellow-gelled Norman 200B strobe is tucked inside Xaero's midsection. To simulate a rocket plume, I clamped an upside-down Nikon SB26 flash, gelled orange, behind the exhaust nozzle. A bare Dynalite 2040 head lit Xaero and Dave's right sides. His left side was lit by a seven-foot Westcott umbrella, fitted with a ½ CTO gel and powered by another Dynalite 2040.

Specs: Canon 1Ds Mark III • 24–105mm at 85mm f/8, $^1/_{60}$ second, and ISO 100

Note: Always bring mounting accessories: clamps, gaffer tape, small ballheads, 1/4 and 3/8 studs, pins, and extenders.

Boeing 733-606-12 Supercruise Demonstrator

A portable, take-anywhere location studio

To mark The Boeing Company's centennial, I photographed a variety of unusual historic artifacts at the company's closely held archives, located in an unmarked Bellevue, Washington office building. The archive is clean but crammed; I was advised that my "studio" would be one 3x6-foot table to work on. Since I was flying there, I decided to pack minimal equipment, and light simply: one studio strobe, with a grid spot attached, positioned high and aimed down on a white 54-inch wide seamless backdrop drop-shipped from Amazon. Here is the studio-in-a-case I put together for the job:

— to support the seamless, one Manfrotto 2983 compact crossbar
— to support the crossbar, two Matthews 389788 compact light stands
— to hold the flash head, Westcott's 6017 telescoping boom arm
— for fill light, one Westcott 30" silver/white reflector
— Dynalite M1000X power pack with one 2040 strobe head
— backup Dynalite M1000X and 2040 head (not used)
— four Dynalite grid spots
— three PocketWizard Plus III transceivers

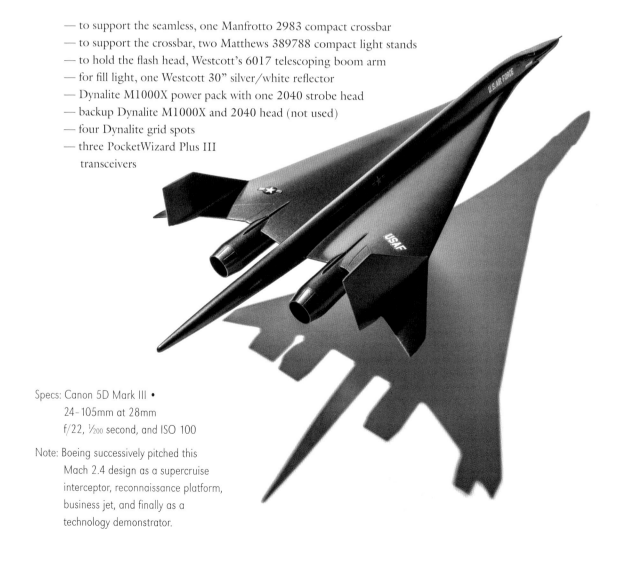

Specs: Canon 5D Mark III •
24-105mm at 28mm
f/22, ½₀₀ second, and ISO 100

Note: Boeing successively pitched this Mach 2.4 design as a supercruise interceptor, reconnaissance platform, business jet, and finally as a technology demonstrator.

University of Montana
Flight Laboratory Wind Tunnel

Softboxes: a perfect choice for even lighting and quick setup

Softboxes—light modifiers with translucent panels that minimize shadows—have fallen out of favor, but there's no better solution for capturing detail. A bonus: they set up quickly.

That proved useful for a two-day magazine assignment to photograph the University of Montana's Bird Flight Lab. I read the text and decided to attempt fifteen different shots. This wind tunnel was by far the coolest. Using strain gauges, lasers, high-speed x-ray video, and cameras that can record 1,000 frames per second, lab researchers analyze avian biomechanics in unprecedented detail.

I set up three small Chimera lightboxes, one above the camera and two on either side. All were positioned at 45-degree angles to the front plexiglass window, to minimize reflections from the lights. A lab assistant introduced the birds, one at a time and perched on a dowel, into the air stream through a hole in the Plexiglas.

The magazine ran one shot as the opener. Then the fun began. After publication, I scanned three of the slides and began extensive postproduction to submit it to my stock photo agency. Replacing the original four birds, I composited seven, and arranged them into a pleasing formation. I changed colors and markings on the duplicate birds. The background grid got cleaned, straightened, and re-scribed. The Plexiglas cover has been retouched out, along with more than a few parakeet "souvenirs" along the bottom of the apparatus. Finally, I darkened the edges to hide most of the room.

Specs: Nikon F5 • 28–70mm at 50mm
 Fujichrome Provia 100F (film)
 f/11, ½₅₀ second, and ISO 100

Note: The T-38 jet trainer's roll rate of 720 degrees per second looks lethargic compared to a barn swallow's 5,000 degrees per second.

The World's Fastest Keychain

No lights, no problem: photographing under overcast skies

With its clear weather and hard-packed dry lakebeds, southern California's high desert was an easy choice when Bell Aircraft went searching for an isolated site to fly America's first jet. The XP-59A Airacomet's first flight, in October 1942, literally launched a golden age of flight test.

Crashes inevitably followed. The early jets and rocket planes were often unstable and always dangerous; dozens of aircraft wound up as smoking holes in the Mojave Desert, too often with loss of life.

Hard on the heels of rescuers, investigators would quickly converge on crash sites. They sifted through debris fields, made photos, retrieved the largest remnants, and departed. Whether through oversight or by design, they often left behind many twisted fragments and scattered parts. Surrounded by Joshua trees and preserved by the dry desert heat, the pieces lay undisturbed for decades.

But in the early 1990s, enthusiasts like Tony Landis and self-designated "aviation archaeologists" Peter Merlin and Tony Moore began systematically finding and cataloging the forgotten sites. They and other wreck chasers donated larger pieces to museums and military affiliates. Smaller pieces were often catalogued and organized by aircraft type; a few found their way onto rings billed as the "world's fastest keychains." I photographed this one, with parts gathered by Tony Landis, on smooth white Foamcore under a thinly overcast sky. The diffused light evened out the colors and textures. The parts are small, an average of one square inch. To keep them in focus, I used Canon's ultra-sharp 100mm macro lens, set at f/22, with the camera on a tripod.

Specs: Canon 5D Mark III • 100mm macro f/22, ¹⁄₂₀ second, and ISO 100

Note: This is my own keychain, with parts from (clockwise, left to right) the B-70, X-10, NF-104, YF-12, X-31, XB-51, X-15, U-2, F-104A, X-2, YB-49, and B-58 crash sites.

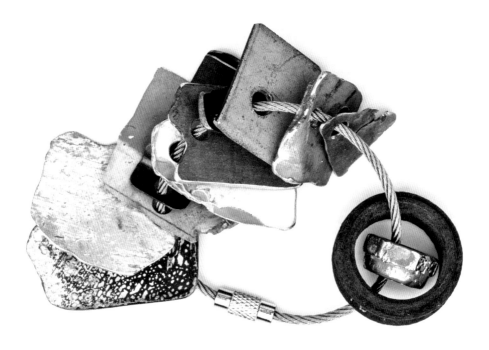

Lockheed Skunk Works Archangel A-3

Network, propose, and write

Specs: Canon 5D Mk III •
24-105mm at 35mm
$\frac{1}{125}$ second, f/14,
and ISO 100

Note: The A-3 featured an
optional horizontal
stabilizer. Omitting it
would reduce radar
returns—Lockheed's
earliest use of stealth.

column to *Air & Space/Smithsonian* magazine on how he had quietly saved the historic artifact over the decades. Bob got clearance, I got the assignment, and my text and photo were published.

So as the Skunk Works' 75th anniversary approached, we wondered if we could get clearance to photograph some of the other secret stuff buried deep in the company's archives. We did. On shoot day, I unrolled a 108"-wide white seamless in the Skunk Works photo studio. Things started mysteriously appearing, apparently handpicked by department heads. I lit each one the same, with a single Dynalite 2040 strobe head fitted with a grid spot and powered by a Dynalite M1000X pack. A 3x4-foot white Foamcore card positioned just out of sight at camera right, provided some soft fill. This model got the cover.

I met Bob Driver at an aviation photography conference, and over a beer that night he casually mentioned he had squirreled away a 1958 model of an early A-12 Blackbird design concept in his Skunk Works office. The A-3 was in a nondescript Samsonite suitcase, he said, the standard way legendary Skunk Works engineer Kelly Johnson snuck supersecret models back east to his CIA meetings. While Bob checked to see if the model could be cleared for publication, I quickly proposed a short 300-word

Republic XF-84H Thunderscreech

Planes on poles at night

Specs: Nikon F5 • Nikkor 35mm • Fuji Velvia (film)
f/8, 8 seconds, and ISO 50

Note: XF-84H pilots living in Rosamond, ten miles
away, knew they'd fly that day because
they could hear the Thunderscreech's early
morning engine runups.

Where there's an airfield, there's often a plane on a pole, pointed skyward as if aching to fly again. I began collecting them with my camera in 1986, as assignments took me to commercial and military airports around the world. They were all shot on Fuji's RVP Velvia slide film, known for its rich, saturated colors. Eventually bored by simply documenting them, I started photographing them at night using only available streetlights. I made no attempt to get accurate color; the weirder, the better.

This Republic XF-84H, the surviving example of only two built, first flew in 1955. It was an experimental turboprop-powered aircraft whose supersonic propeller tips created an unbearably loud noise signature, earning it the unofficial and very unaffectionate nickname "Thunderscreech." After just twelve test flights (ten of which resulted in emergency landings),

the program was canceled. One aircraft was cannibalized for its huge Allison XT-40 engine, but this one spent the next three decades perched at the entrance to Meadows Field Airport in Bakersfield, CA.

Military services impose strict rules on obtaining, displaying, and maintaining surplus aircraft that are donated to communities. They also reserve the right to retrieve the planes—which happened here in 1992. Although a flight test failure, the jet's rarity led the U.S. Air Force to reclaim, restore, and relocate the Thunderscreech to its National Museum.

When I learned the Thunderscreech would be removed, I drove to the airport and spent an early evening recording it, using Nikon's 35mm Perspective Control shift lens to control keystone distortion.

Trans World Airlines Winter Uniform

Supplementing museum lighting

Airline uniforms, particularly those worn by female flight attendants, serve varied and often contradictory purposes. They must be comfortable, reinforce the airline brand, travel well, echo the carrier's national origin, and be neither ahead of nor behind prevailing fashion trends. This winter uniform was designed by French fashion house Pierre Balmain, and worn by TWA flight attendants from 1965 to 1968. It belongs to a small collection on display at the Santa Monica Museum of Flying. The Museum's overhead light, through sheer luck, defined mannequin's face perfectly. I only added a touch of hard strobe fill light to open the shadows beneath the cap and to add catchlights in the eyes. To focus attention on the face, I vignetted the photo's corners in postproduction.

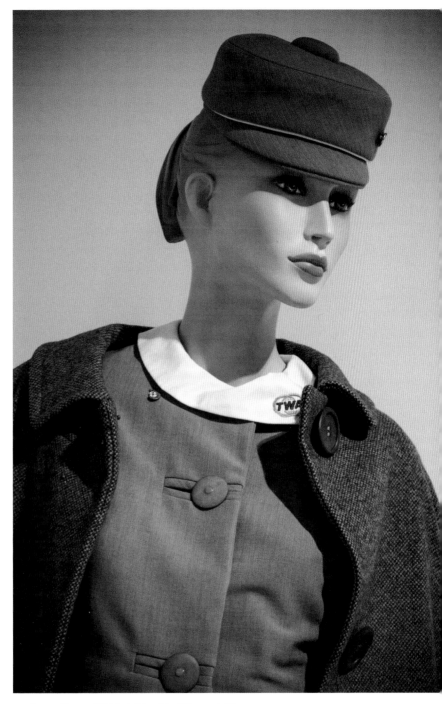

Specs: Canon 5D Mark IV • 24-105mm at 90mm
f/22, 2 seconds, and ISO 400

Note: One TWA uniform had a foldable lapel that attendants buttoned over the airline's distinctive logo when taking a cigarette break in public.

TRW Post-Boost Vehicle with Nuclear Warheads

Blending overcast sky light with studio strobe fill

The sun, diffused by a thin layer of clouds, provides cheap, abundant light for photographing aviation artifacts like this old model from TRW's in-house shop. It and a similar nuclear warheads model came to light when a storage facility's contents were sold off for non-payment. The only documentation accompanying it was a booklet dated 1981 that described the MX missile's control system. Almost certainly, program records were classified, shredded, or both. This model revealed configurations allowing for 38 small or six large thermonuclear warheads.

It looked great on a single 3x4-foot white Foamcore card atop the driveway, with another card propped behind it as backdrop. But the diffused sky alone did not reach into the shadows. I set up an AlienBees B1600 strobe, fitted with a Westcott 32" shoot-through umbrella, behind and above the camera. With the camera set for the ambient overcast lighting, I dialed down the flash output until its light filled, but not overwhelmed, the sunlight.

Specs: Canon 5DS • 24–105mm at 85mm
f/16, ¹⁄₅₀ second, and ISO 200

Note: The model's only clue is its nameplate: TRW Systems/Advanced PBV Study/Pusher Type Bus/Three Degrees of Freedom.

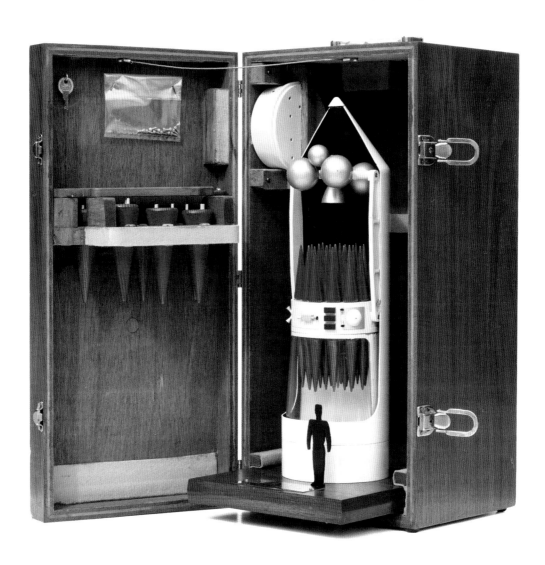

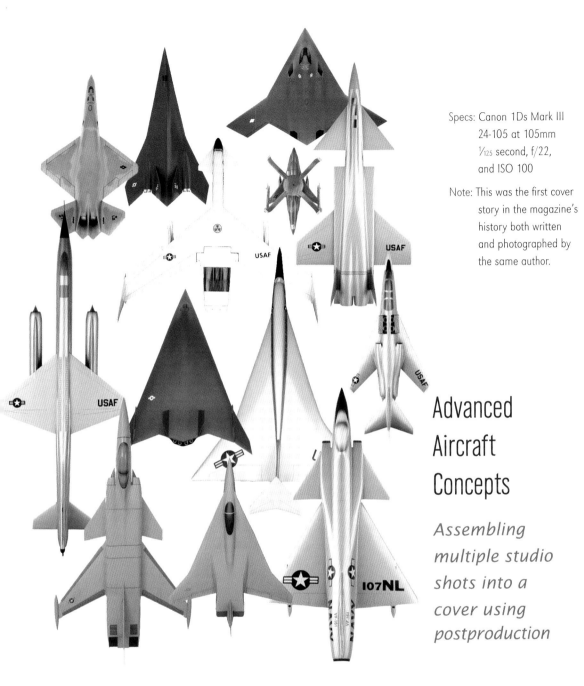

Specs: Canon 1Ds Mark III
24-105 at 105mm
$\frac{1}{125}$ second, f/22,
and ISO 100

Note: This was the first cover
story in the magazine's
history both written
and photographed by
the same author.

Advanced Aircraft Concepts

Assembling multiple studio shots into a cover using postproduction

I proposed, then wrote and photographed, a cover story that ran in *Air & Space/Smithsonian* magazine centered on models of advanced aircraft that aerospace company shops make. I envisioned the cover as a collage featuring various shapes and colors. The models were photographed individually on white seamless paper, crosslit by two small Chimera softboxes, at Northrop Grumman and at the private collections of John Aldaz and Jonathan Rigutto. I retouched out all shadows, and then submitted the final image as a huge TIFF file with each model on its own layer. The art director then shifted and overlapped the models to fit the cover proportions, leaving room for the magazine title and the cover captions.

A Guide to Some Useful Tools and Equipment

Following is a biased guide to the gear mentioned in preceding pages. It was accurate when we went to press, but I guarantee that the photography industry's penchant for change at the speed of light will render some listings obsolete. Check the Internet for updates.

- Adobe Photoshop CC The ultimate tool for adjusting color and exposure.
- Adobe Photoshop Lightroom A great tool for preliminary editing.
- Canon EOS 5D Mark IV DSLR Versatile, fast, accurate, and intuitive—the perfect camera.
- Canon EOS 5DS DSLR Megapixels and more.
- Canon L lenses:
 — EF 15mm f/2.8 semi-fisheye lens with 180 degree diagonal point of view.
 — EF 16-35mm f/2.8L III USM The gold standard for shooting interiors.
 — EF 17-40mm f/4L USM An affordable zoom for business aircraft interiors.
 — 24mm TS-E f/3.5 II Sharp tilt-shift lens with very wide coverage, good for shooting galleys.
 — 24-105mm f/4 II IS The perfect all-around lens on the ground and in the air.
 — 45mm TS-E f/2.8 The go-to lens for forensic ground shots of aircraft.
 — 50mm TS-E f/2.8L The promising successor to Canon's 45mm TS-E, introduced as we go to print.
 — 70-200mm f/2.8L IS II USM A perfect complement to the 24–105mm lens for portraits and details.
 — EF 100mm f/2.8L Macro IS USM With its image stabilization, ideal for artifact closeups and copy art.
 — EF 100-400mm f/4.5-5.6L IS II USM Best lens possible when shooting ground to air.

- Canon RS-80N3 electronic cable release A must-have whenever you use a tripod.
- Canson 14x17-inch 50-lb. tracing paper, 50-sheet pad Ideal for covering CitationJet and other cabin windows.
- Chimera 36x48-inch Medium Lightbank Lightweight and extremely durable softbox.
- David Clark H10-13.4 headset The industry standard in general aviation.
- Dynalite M1000X power pack Reliable, never-fail strobes; superseded by the even better RoadMax series.
- Dynalite Model 2020 flash head Tough and compact; superseded by the more powerful MH2065V.
- Dynalite Model 4040 studio flash head Out of production but the diffused dome is perfect inside a light box.
- Fray Check liquid sealant Frustrating to apply, but it seals cloth template edges extremely well.
- Green Pod GR0079 Small bean bag that holds a camera/lens combination atop a business jet chairback.
- Hill & Usher/The Hartford Affordable liability insurance with astoundingly good Certificates service
- ICOM IC-A14 VHF air band transceiver Low-cost, high quality radio to monitor aircraft movements.
- Kenyon KS-6 Gyro Stabilizer When even image stabilization falls short on your lens.
- Leitz 14119 mini ball head Superb gripping power; long out of production but seen on eBay.
- Lightspeed Tango headset Indifferent customer service but the best wireless headset to date; long battery life.
- Lowel Tota-light Versatile, compact, and cost effective continuous tungsten lighting source.
- MacPhun's Tonality photo software For Mac users, total control for converting color to black and white.

- Manfrotto 131D lateral side arm Ingenious tripod extender enabling you to project a camera past the roof.

- Manfrotto 2983 compact crossbar Airplane-transportable crossbar for holding 54-inch seamless paper.

- Manfrotto 1004BAC light stand Strong and tall, and nests into each other for easy transport.

- Manfrotto Super Clamp Its multiple accessories enable multiple uses for holding anything, anywhere.

- Manfrotto Neotec 458B tripod Hard to find, but no other tripod is as fast to use, with no loss of versatility.

- Matthews 389788 compact light stands Compact but sturdy, for crossbars or flash heads

- Matthews Roadrags 18x24-inch scrim frame/ black flag Useful for quelling cockpit panel reflections.

- Metolius Safe Techs climbing harness. It is light, strong, and easy to use when shooting from open aircraft and helicopter doors.

- Nikon lenses (both out of production but often available on eBay):
 - —28mm PC-Nikkor f/3.5 PC A sharp wide-angle lens for correcting perspective on small ramps.
 - —35mm f/ 2.8 PC My second-favorite perspective control lens, used with a Nikon-to-Canon adapter.

- Nikon SB-26 shoe-mount flash When set on manual, powerful and reliable wheel backlights; cheap and plentiful on eBay.

- Norman A200C strobe kit Its power packs are outdated, but the small LH2K lamp heads make them easy to hide.

- Norman A400B strobe kit An outdated and heavy design, but the LH52K heads are small and seriously powerful.

- Paul Buff AlienBees B1600 flash head Inexpensive, powerful, and versatile, with matchless customer service.

- Paul Buff Vagabond Lithium battery The perfect location power source for Buff Alien-Bees strobes.

- Pelican 7060 flashlight Small, long-lasting flashlight ideal for light painting with its daylight-quality beam.

- Performix Plasti Dip (black) Four or five coats of this on an adapter ring will protect windows from lenses.

- PocketWizard Flex TT6 radio transceiver Successor to the TT5, used to remotely trigger speedlights.

- PocketWizard Plus III Powerful, reliable, and extremely tough radios for remotely triggering strobes and cameras.

- Really Right Stuff BH40 Ballhead Ridiculously expensive and ridiculously good.

- Really Right Stuff TFA-01 Pocket 'Pod tripod with BH-25LR ballhead Rock solid, on-your-belly tripod.

- Scotch Green #2060 Use this when Scotch Blue tape won't hold diffusion paper on a waxed fuselage.

- Scotch Blue #2090 painters tape Perfect for taping diffusion materials over jet windows with no damage to paint.

- Sekonic L-358 ambient/flash meter Useful for ensuring consistent strobe lighting along a jet's fuselage.

- Sekonic PocketWizard RT-32CTL module An add-on that allows the the Sekonic L-358 to trigger PocketWizards.

- Seth Cole #58 (16-lb.) parchment paper The 24-inch roll is well sized for making Gulfstream window diffusion panels.

- Sunbounce 42x68-inch reflector A compact, windproof reflector with multiple lighting uses.

- Westcott 32-inch shoot-through umbrella Produces beautifully soft light, with honest color temperature.

- Westcott 6017 telescoping boom arm Sturdy but compact boom for holding strobe heads.

- Westcott Ice Light II Expensive but well made light source for painting with light in cramped quarters.

Index

Wicked Weather
A VISUAL ESSAY OF EXTREME STORMS

Warren Faidley's incredible images depict nature's fury, and his stories detail the weather patterns on each shoot. *$24.95 list, 7x10, 128p, 190 color images, index, order no. 2184.*

Rock & Roll CONCERT AND BACKSTAGE
PHOTOGRAPHS FROM THE 1970S AND 1980S

Peter Singer shares his photos and stories from two decades behind the scenes at classic concerts. *$24.95 list, 7x10, 128p, 180 color images, index, order no. 2158.*

Trees in Black & White

Follow acclaimed landscape photographer Tony Howell around the world in search of his favorite photo subject: beautiful trees of all shapes and sizes. *$24.95 list, 7x10, 128p, 180 images, index, order no. 2181.*

Big Cats in the Wild

Joe McDonald's book teaches you everything you want to know about the habits and habitats of the world's most powerful and majestic big cats. *$24.95 list, 7x10, 128p, 220 color images, index, order no. 2172.*

Owls in the Wild
A VISUAL ESSAY

Rob Palmer shares some of his favorite owl images, complete with interesting stories about these birds. *$24.95 list, 7x10, 128p, 180 color images, index, order no. 2178.*

Rocky Mountain High Peaks

Explore the incredible beauty of America's great range with Brian Tedesco and a team of top nature photographers. *$24.95 list, 7x10, 128p, 180 color images, index, order no. 2154.*

Polar Bears in the Wild
A VISUAL ESSAY OF AN ENDANGERED SPECIES

Joe and Mary Ann McDonald's polar bear images and Joe's stories of the bears' survival will educate and inspire. *$24.95 list, 7x10, 128p, 180 color images, index, order no. 2179.*

Rescue Dogs
PORTRAITS AND STORIES

Susannah Maynard shares heartwarming stories of pups who have found their forever homes. *$21.95 list, 7x10, 128p, 180 color images, index, order no. 2161.*

Hubble Images from Space

The Hubble Space Telescope launched in 1990 and has recorded some of the most detailed images of space ever captured. *$24.95 list, 7x10, 128p, 180 color images, index, order no. 2162.*

Storm Chaser
A VISUAL TOUR OF SEVERE WEATHER

Photographer David Mayhew takes you on a breathtaking, up-close tour of extreme weather events. *$24.95 list, 7x10, 128p, 180 color images, index, order no. 2160.*